How To Weld Silverware Animals
Metal Art Welding Projects For Fun and Profit

Written by
Barbie The Welder

Photography & Cover Design
Dan Hundycz

Also Written By Barbie The Welder

Horseshoe Crafts; More Than 30 Easy Projects You Can Weld At Home

The Inspiration Blueprint; How To Design And Create Your Inspired Life

Dedicated with gratitude to Donald

Table of Contents

DEAR ARTIST .. 7

HOW TO NOT SET YOURSELF ON FIRE! 8

HOW TO STICK STUFF TOGETHER ... 9

SHARE YOUR ART, GET FEATURED, & WIN! 14

CRICKET .. 15

FISH .. 19

DRAGONFLY .. 21

SNAIL ... 23

SCORPION ... 26

CRAB .. 30

OCTOPUS ... 34

SEA TURTLE ... 38

LIZARD .. 42

BEETLE	48
PENGUIN	52
BUNNY	56
DOG	61
CAT	65
MOUSE	69
FROG	72
PEACE FROG	76
DUCK	77
TURKEY	82
GOAT	86
BIRD	90
BUTTERFLY	95
DEER	101

ELEPHANT	106
ANT	111
GIRAFFE	116
GOOSE	121
SPIDER	128
LOBSTER	134
FLAMINGO	141
PORCUPINE (FORKUPINE)	151
SHOW ME THE BUNNY!	156
ABOUT BARBIE	157

Dear Artist

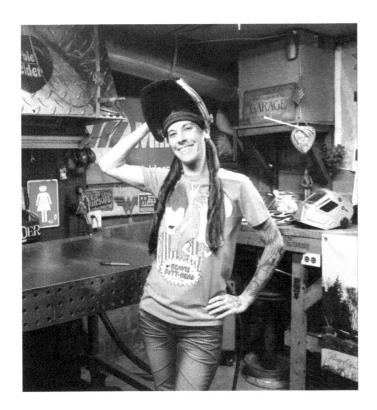

Silverware art is only limited by your imagination! As you complete each project your mind will adapt to creating with silverware and ideas for more advanced sculptures will begin to come to you.

Silverware is a great medium to create with! It is inexpensive, easy to find, and comes in a wide variety of patterns and designs that make each project unique. By using silverware with different patterns, you can make the same project and it will look different! Silverware can be found at rummage sales, second hand stores, your mom's silverware drawer, or restaurant supply stores. (Taking silverware from your mom's silverware drawer is a horrible idea, is not recommended, and the reason my dad makes me clap my hands the entire time I'm in their kitchen, so he knows I'm not stealing their silverware!)

Have fun and happy welding!
With love and gratitude, Barbie

How To Not Set Yourself On Fire!

Safety is no accident!

Welding, cutting, and grinding metal is extremely dangerous if you are not taking the proper precautions. By following these simple steps you will be able to happily and safely weld for many years to come!

- Keep your work area free from clutter
- Keep any papers, flammable materials, and oily rags away from your work area
- Make sure your work area has the proper ventilation
- Have a fire extinguisher close by your work area when you are welding
- Always wear fire resistant clothing and keep your skin covered as you weld
- Always wear proper fitting clothing, loose fitting clothing are easier to catch on fire and can quickly get caught up in a grinder

- Make sure your pantlegs are long enough to cover the tops of your shoes/boots
- Protect your feet with leather boots/steel toe shoes
- Always wear a welding helmet with the correct shade lens while welding
- Hearing protection, safety glasses, and a face shield should be worn each time you cut or hammer metal
- Always wear leather gloves to protect your hands and wrists as you weld and work with metal.
- Always make sure anyone in the shop with you is also following these safety precautions

How To Stick Stuff Together

There are several welding processes that are used in the welding and art industries, but I will only speak for the two I use, MIG and TIG. Both MIG and TIG are fantastic for creating art and each process has its advantages and disadvantages.

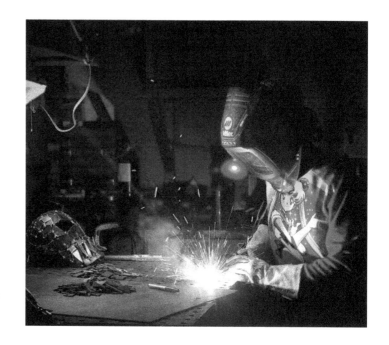

In my opinion MIG welding is easier to learn, less expensive to get started, and welds faster, but when using it to weld you will have more cleaning. TIG welding takes more time to learn, but is more precise, you make smaller cleaner welds, and you have very little clean up.

When I weld silverware art, I use my MIG welder with 75/25 gas and .030 ER70s wire. Each welder has their own preferences as to what they use, what works for some might not work for others. Use what you are comfortable with.

Welding is an art before you ever do anything else with it! If you are new to welding, like anything you try that is new, it will take time to learn your machine and improve your skills, have patience with yourself!

Setting up your welder correctly will give you the best results when welding. If you are MIG welding the thickness and type of material you're welding, the wire thickness and whether or not you're using gas will all effect the settings of your machine. If you are using a TIG welder to create your art, the thickness of your material, tungsten size, and filler rod size will all determine your machine settings. Each welder, whether MIG or TIG will have a basic parameter chart (machine settings) that is usually on the backside of the door. If the chart is not on the machine look it up on the manufacture's website. These settings will give you a starting point where to set your machine, but they may need to be adjusted from here. If you are new to welding use practice pieces to tune in your machine before you start welding and creating art. There are a ton of fantastic videos on YouTube that will help you properly set up your machine. Having your settings correct for the job you are working on will make a big difference in your welding experience! For most of these welding projects you will be using small tack welds to weld your projects together. Tack welds are small dots of weld similar to the size and shape of candy dots, the rainbow color candy that come on a long strip of paper. (Yummy, now I want candy!)

My favorite resource for any welding questions is Jody Collier, the man behind the Welding Tips and Tricks website and YouTube channel. Jody is an incredible wealth of information, the one the seasoned welders go to when they need answers!
Website: www.WeldingTipsAndTricks.com
YouTube: www.YouTube.com/user/WeldingTipsAndTricks
Instagram: www.Instagram.com/Weldmonger

In addition to a welder and your imagination you will need a few tools to create these sculptures.
- Metal top work bench
- Wire brush

- Vise or clamp
- Hammer
- Chisel
- Tape measure
- Whelpers or needle nose pliers
- Angle grinder or pneumatic grinder with a cut off wheel and sanding disk
- Clear coat spray
- Random shop scrapings (nuts, bolts, tiny ball bearings, etc. to use for eyes and other features you would like to add to your sculptures.)

When I started creating metal art, I didn't have much to work with and had to use my imagination and sometimes do things in an unconventional way. (I mostly still do!) If you don't have a metal bench you can put a sheet of 14-gauge steel between two saw horses. If you don't have an angle grinder with a cut off wheel and sanding disk you can bend the silverware back and forth until they break and then hand file any rough edges. There is always a workaround for any situation! When choosing silverware for your projects, stainless steel and steel silverware may be used, but silver-plated silverware cannot. Steel filler rod can be used to weld

stainless steel silverware, but it must be clear coated when the project is finished to prevent rust.

Deburring, smoothing, and shaping: When you cut metal it leaves a burr, a sharp edge. Deburring something means to remove any sharp edges so that you can safely run your fingers over a piece of metal without getting cut. Smoothing and shaping refers to using a grinder to shape a piece to look like it was never cut. Each piece that you cut will need to be deburred and smoothed.

Clean Up and Finishing: When you are done welding your beautiful art, it is of utmost importance that you carefully clean it. Use a wire brush to clean any weld discoloration and a hammer and chisel to chip any weld spatter from your sculpture. Weld spatter can hurt someone when they pick up your masterpiece and cleaning any weld discoloration with a wire brush just looks better! Your attention to details will keep your art heads and shoulders above the crowd! Pride in craftsmanship always!!!! To finish my projects, I use a rattle can (spray paint) clear coat made for metal, it gives the sculpture a beautiful patina and keeps it from rusting.

Difficulty levels for the projects are shown in forks, ✦ , one fork being the easiest and five forks the most difficult. If you are new to welding art start with the easier projects. Yes, I know, I am welder hear me roar! Lol, hear me out! When you start with the easier projects, are able to create them, and love what you create, you build confidence in yourself and will keep creating. If you start with the harder projects, you may get frustrated and give up something that will bring you and the people around you joy!

Share Your Art, Get Featured, & Win!

I can't wait to see what you are going to make! No, really, I want to see what you are going to make using this book! Post your finished projects to Instagram and tag

#BarbieTheWelderAnimals

so I can see all your wonderful silverware animal sculptures! Not only will I see what you are making I'm going to feature one project every week on my Instagram page and give you a shout out so make sure to tag all your silverware animal pictures! Sometimes I will choose the weekly winner and sometimes I will let you choose the winner from a few of the entries!

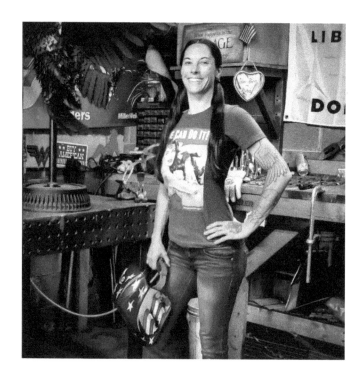

Everyone who is featured on my page will automatically be entered to win a one of a kind Barbie The Welder sculpture that I will be making and giving away at the end of the year. Not only will you get to vote for the winner you will also get to vote and decide what sculpture I will be making for the winner!

Follow @BarbieTheWelder on Instagram and turn your notifications on so you don't miss out!

Cricket

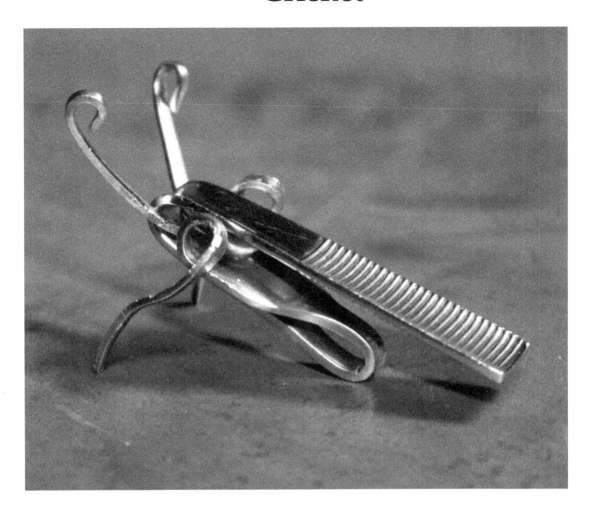

Difficulty Level

Materials:
 1 fork
Tools:
 Vise or clamp
 Hammer
 Needle nose pliers
 Clear coat

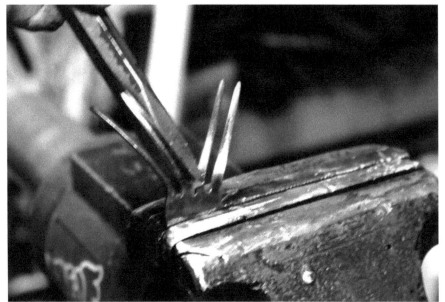

No welding needed in this project, sorry! Clamp the fork at the base of the tines and spread the tines out so the center makes a V. I use my chisel to pry the tines apart

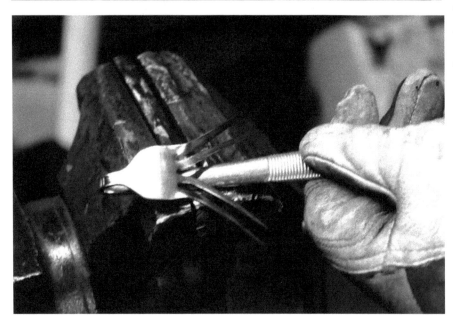

Bend the handle backwards until it's flat on the fork tines.

Clamp the fork and continue bending the fork handle forward over the V.

Fold the handle down until it is flush. This creates the body of the cricket.

Hold the body of the cricket in one hand and use pliers to bend the outside tine back and over making a loop.

Slightly bend the front of the fork tine down. Loop and bend the outside tine on the opposite side.

Loop the tips of the two inside tines to create antenna.

Fish

Difficulty Level

Materials:
 1 spoon
 1 fork

Tools:
 Vise
 Grinder with a cutoff wheel and sanding disk
 Hammer
 Chisel
 Paint pen or marker
 Wire brush

Mark and cut the spoon and fork at the handle base position. Mark and cut the fork at the tine base position.

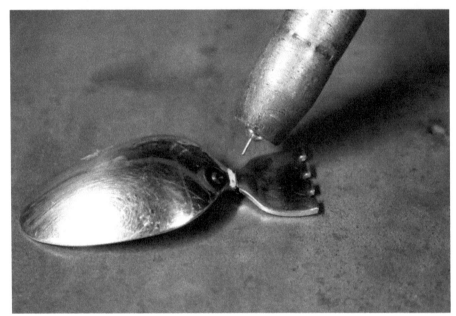

Hold the handle end of the fork tine piece up to the handle cut end of the spoon bowl and tack weld them together with two or three small tacks.

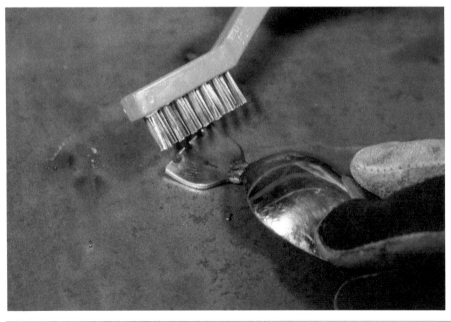

Clean any weld discoloration with a wire brush and chip any spatter with a hammer and chisel.

Dragonfly

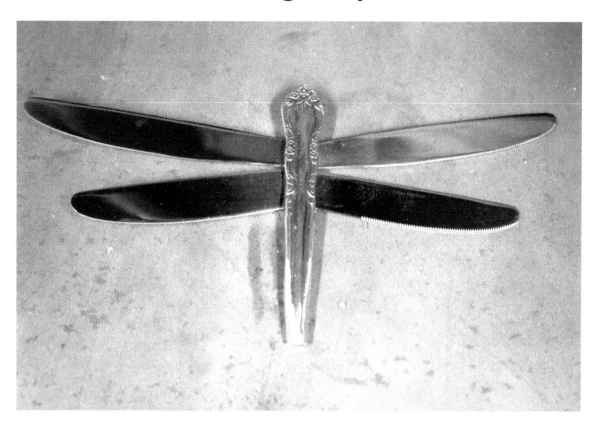

Difficulty Level

Materials:
 4 knives

Tools:
 Vise
 Grinder with a cutoff wheel and sanding disk
 Marker
 Wire brush
 Hammer
 Chisel

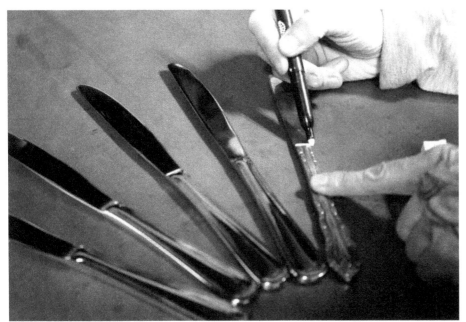

Mark and cut two knives at the handle base position and two knives 1' up the blade from the knife base position.

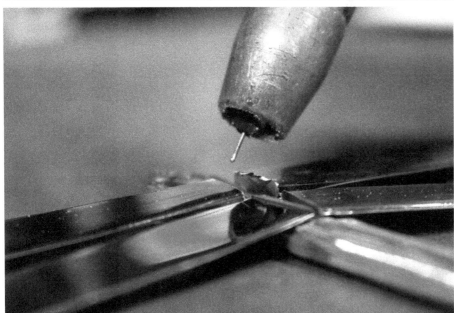

Place the two long knife blades on a handle 1" from the wider end angling them forward. Place the two shorter blades directly behind them angled backwards. Tack weld the four blades onto the handle.

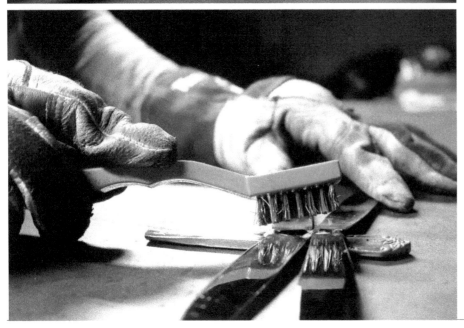

Clean any weld discoloration with a wire brush and chip any spatter with a hammer and chisel.

Snail

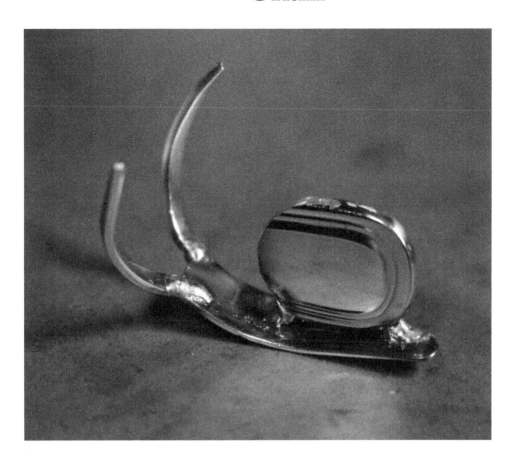

Difficulty Level

Materials:
 1 butter knife
 1 large fork
Tools:
 Vise or clamp
 Grinder with a cutoff wheel and sanding disk
 Hammer
 Chisel
 Wire brush
 Marker

Mark and cut one inch off the handle end of the knife for the shell.

Mark and cut two tines from the fork for the antenna.
Mark and cut two inches off the buttering end of the knife for the body.

Round the shell using a grinder.

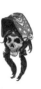

Give the body a slight curve by clamping it and bending it using a hammer.

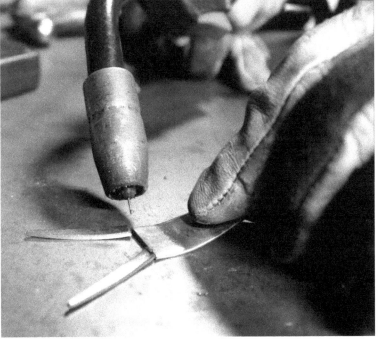

Hold the body with one hand and place the antenna up to the head. Gently tack weld each antenna onto the body.

Hold the shell on the center of the body and tack weld the front and back of the shell.

Use a wire brush to clean any weld discoloration and a hammer and chisel to chip any spatter.

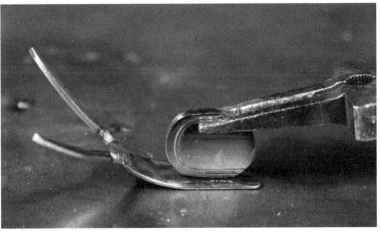

Scorpion

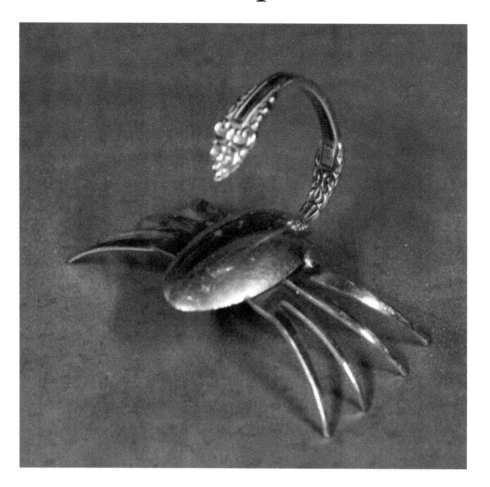

Difficulty Level

Materials:
- 1 large spoon
- 2 forks

Tools:
- Vise
- Grinder with a cutoff wheel and sanding disk
- Hammer
- Chisel
- Marker
- Wire brush

Mark and cut the two forks at the handle base position.

Clamp the fork tines one at a time and pry the tines apart.

Curve the fork tines by holding the one end and hammering the tines around a piece of pipe or the back of your vise.

Hold the spoon by the bowl and hammer the handle around towards the back of the spoon bowl.

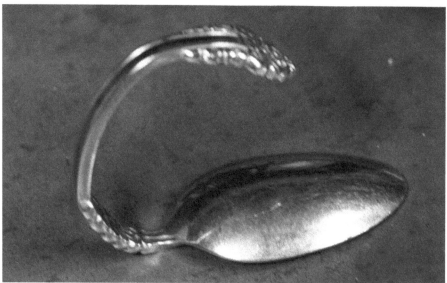

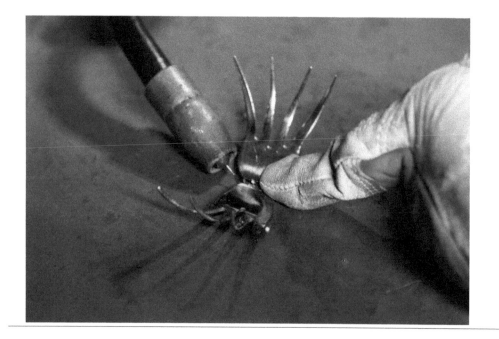

Hold the fork tines, legs, curved side up and tack weld them once on each side.

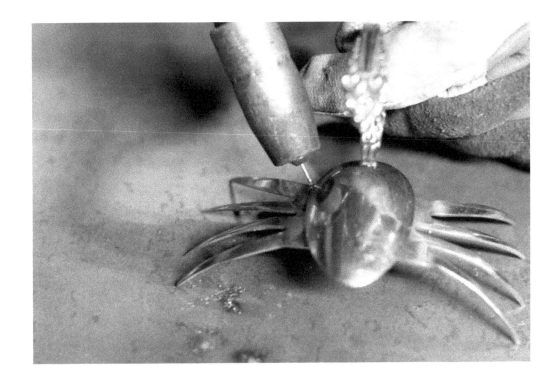

Stand the legs up and center the body over the legs. Tack weld them together at the front and back of each set of legs.

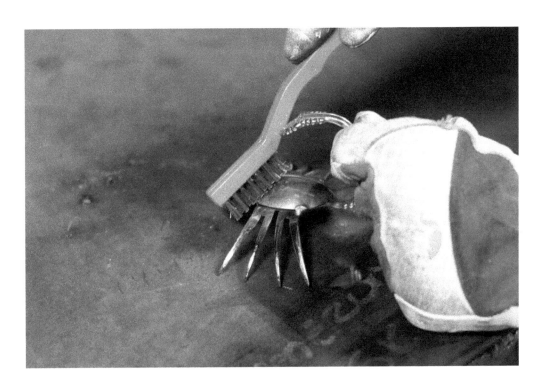

Clean any weld discoloration with a wire brush and chip any spatter with a hammer and chisel.

Crab

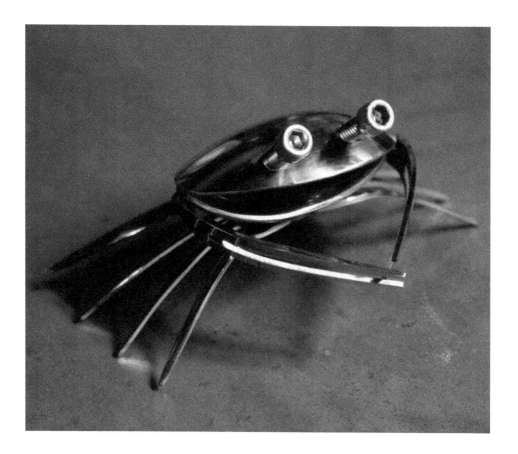

Difficulty Level

Materials:
- 2 spoons
- 3 forks
- 2 bolts for eyes

Tools:
- Vise
- Grinder with a cutoff wheel and sanding disk
- Hammer
- Chisel
- Marker
- Wire brush

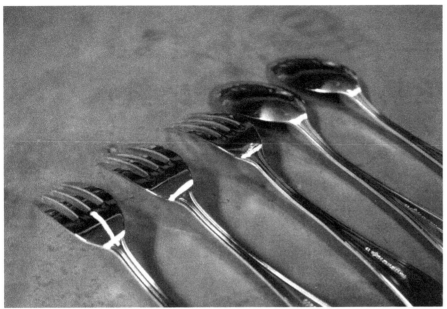

Mark and cut the two spoons at the handle base position for the top and bottom of the shell. Mark and cut two forks at the handle base position for the legs. Mark and cut one of the forks at the handle base position and down the center of the tines to create the claws

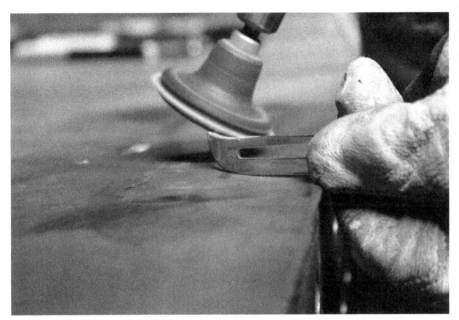

Smooth and deburr the two half tine claw pieces.

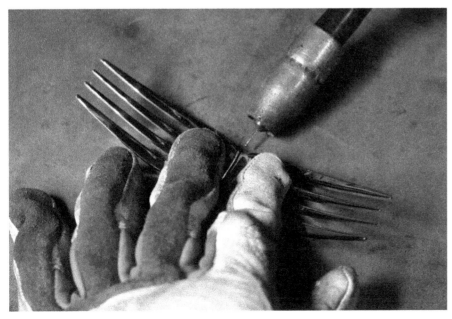

Hold the two tine pieces together and tack weld them once on each side.

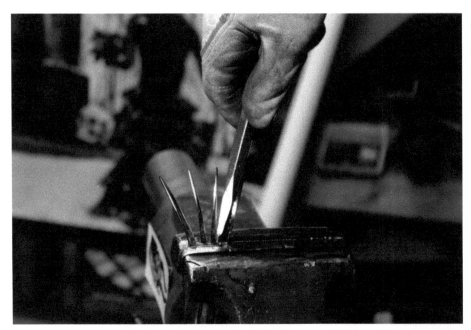

Clamp the welded legs and separate the legs using a chisel

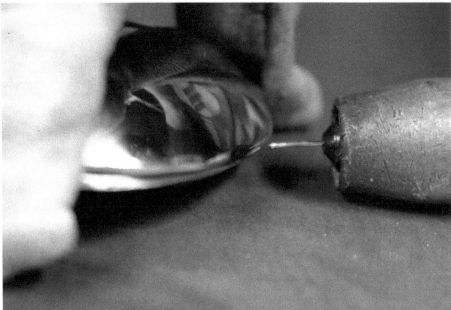

Hold the two spoon bowls, shell halves, on top of each other, back side of the bowls out. Touch the back together and leave the front slightly opened, and tack weld them together at the back.

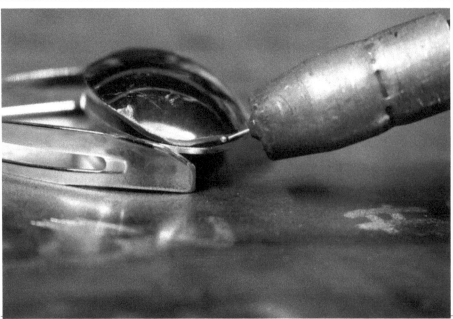

Set the shell on the bench and lean the claws up to the left and right side and tack weld each one in place where the two touch.

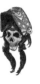

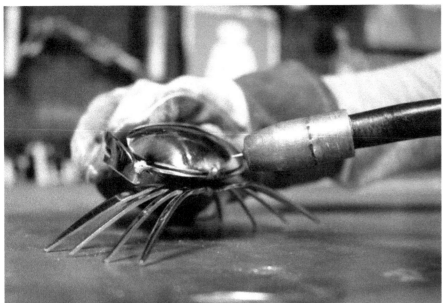

Set the legs down and place the shell body on top. Angle the body slightly up making the gap in the back between the body and legs smaller and tack weld the two pieces together

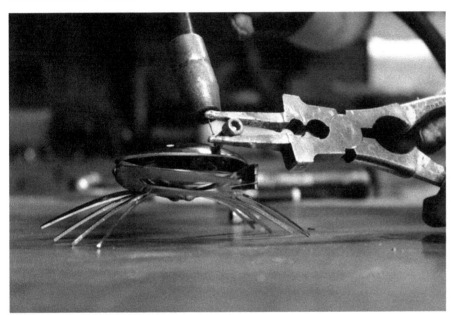

Hold the eyes with pliers and tack weld them on.

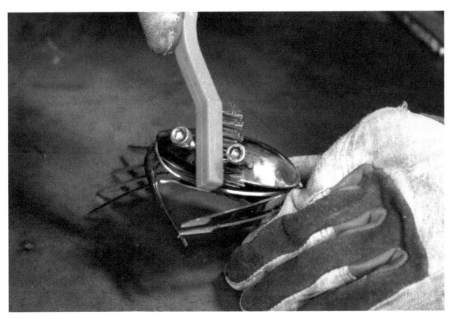

Clean any weld discoloration with a wire brush and chip any spatter with a hammer and chisel.

Octopus

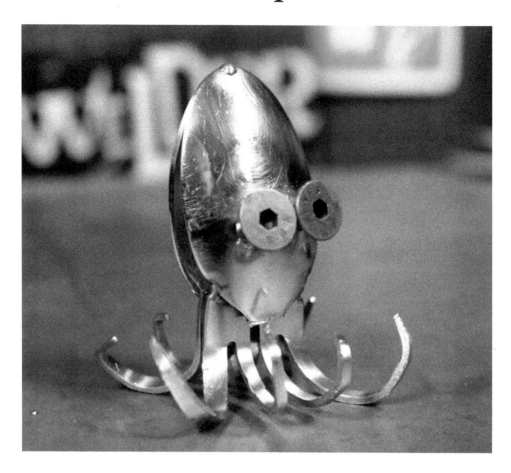

Difficulty Level

Materials:
- 2 spoons
- 2 forks
- 2 eyes

Tools:
- Vise
- Grinder with a cutoff wheel and sanding disk
- Hammer
- Needle nose pliers
- Chisel
- Marker
- Wire brush

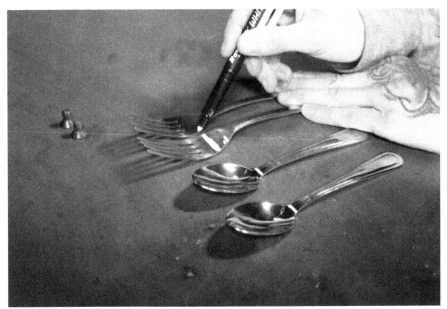

Mark and cut the two spoons at the handle base position. These pieces will become the body. Mark and cut the two forks 1/2" above the tines. These pieces will become the tentacles

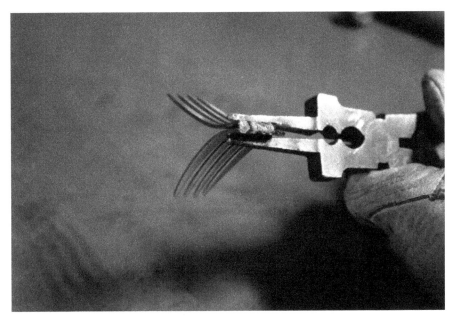

Hold the two tine sections together back to back and weld them using small tack welds.

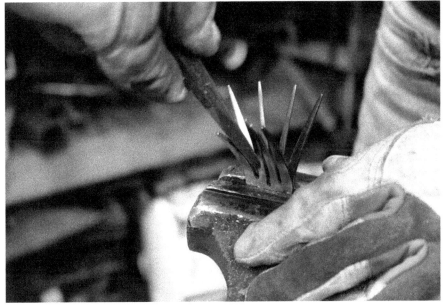

Clamp the tines and pry them apart.

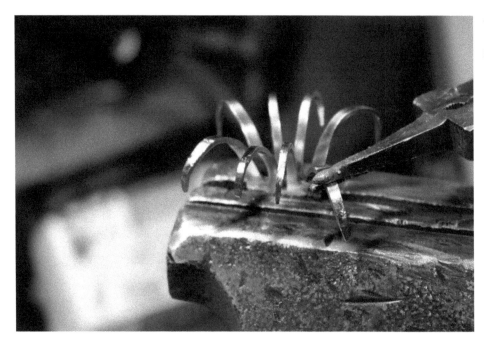

Using pliers curl and separate the tentacles.

Use pliers to hold an eye on the back side of a spoon bowl and tack weld it in position using two small tack welds. Tack weld the other eye on.

Hold the two spoon bowls and tack weld the top of the head using two small tack welds.

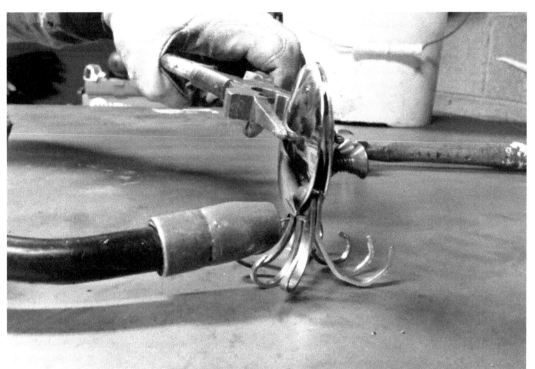

Open the bottom of the body slightly and place it over the tentacles. Align the body straight and tack weld the tentacles to the body once on each side front and back. Clean any weld discoloration with a wire brush and chip any spatter with a hammer and chisel.

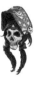

Sea Turtle

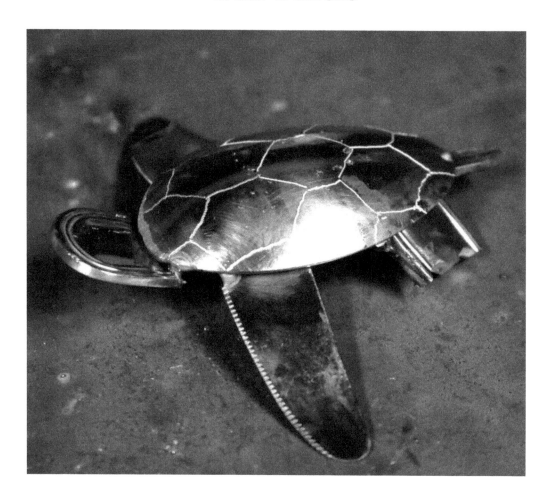

Difficulty Level

Materials:
- 1 spoon
- 2 knives

Tools:
- Vise
- Grinder with a cutoff wheel and sanding disk
- Marker
- Hammer
- Chisel
- Wire brush
- Engraver to make shell markings

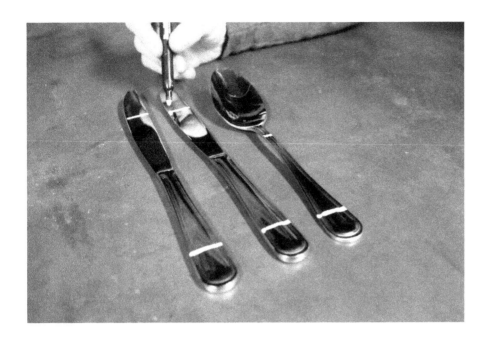

Mark and cut the three handles 1" from the end.
Mark the two knife blades 1.5" from the end.
Mark and cut the spoon at the handle base position and again 1" up the handle.

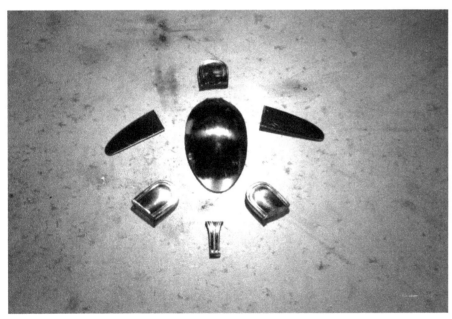

Clamp the two back flippers in the vise one at a time and use the edge of your cut off wheel to cut them like shown.

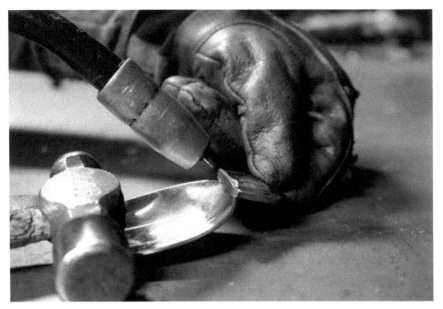

Place the spoon bowl upside down and hold the head up to the wider end and tack weld it on in two places.

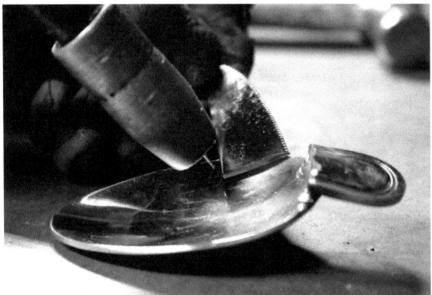

Hold the knife blade, flipper, up to the front and tack weld it on in two places. Repeat with the other front flipper.

Hold the back flipper up to the back of the turtle and tack weld it on in two places. Repeat with the other back flipper.

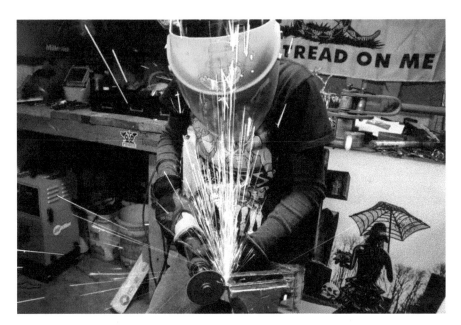

Shape the tail piece to a point at one end.

Hold and weld the tail to the south end of your turtle.

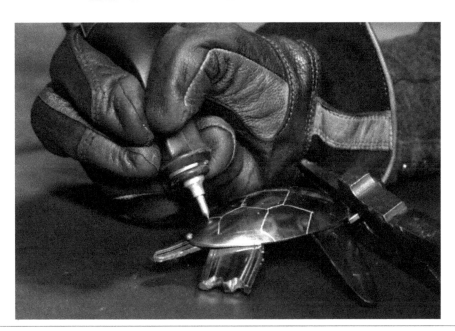

Using an engraver draw markings on the shell.

Clean any weld discoloration with a wire brush and chip any spatter with a hammer and chisel.

Lizard

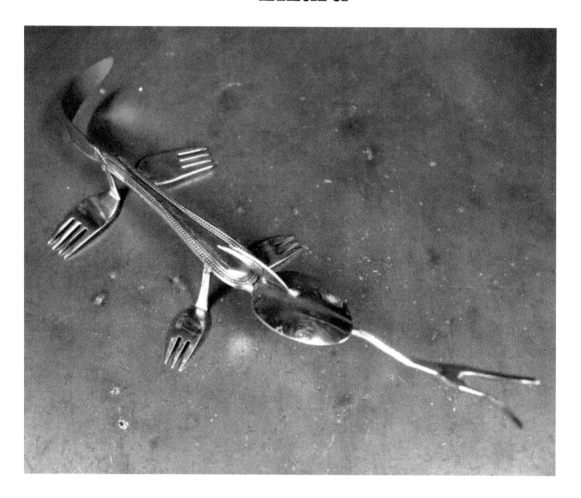

Difficulty Level

Materials:
- 2 spoons
- 5 forks
- 1 knife

Tools:
- Vise or clamp
- Grinder with a cutoff wheel and sanding disk
- Hammer
- Chisel
- Marker
- Wire brush

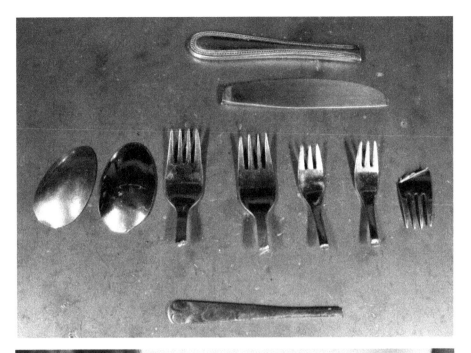

Mark and cut the two spoons at the handle base position.
Mark and cut four forks 1" above the handle base position.
Mark and cut the knife at the handle base position.
Mark and cut a fork at the handle base position and again at a 45% angle across the tine section.

Mark a line 1.5" down the center of the fork handle and cut on the line to create the tongue.

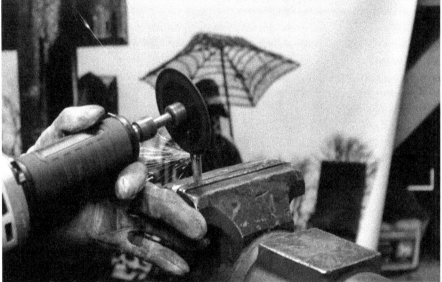

Smooth and deburr the tongue.

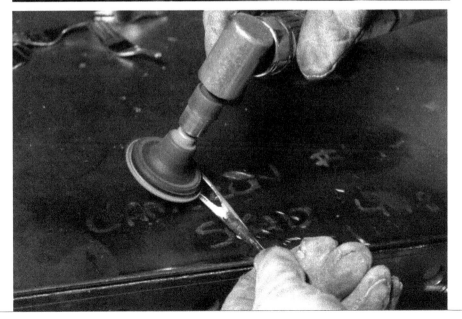

Tongue cut and deburred.

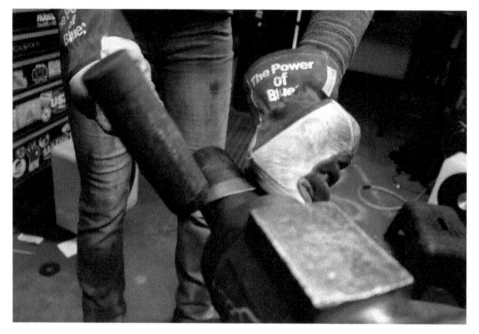

Hold the knife blade and curve it by hammering it over a round surface.

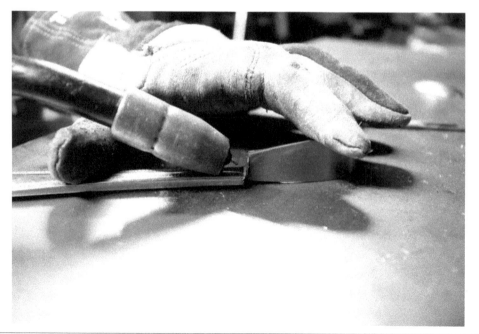

Tack weld the knife blade back on the knife handle sideways from its original position.

Grind the weld between the blade and handle smooth.

Tack weld the tongue into one of the spoon bowls.

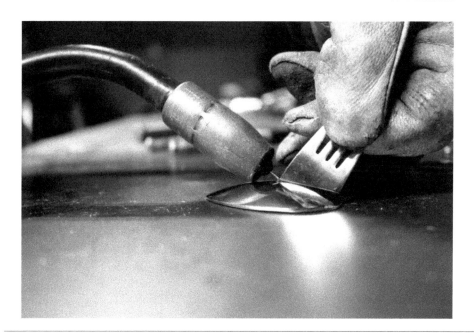

Tack weld the fork tine section that was cut at a 45-degree angle on the top of the other spoon bowl towards the back with the tines angling back.

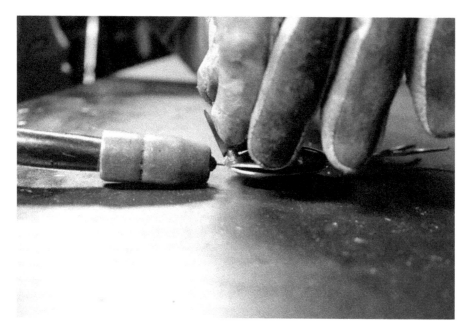

Hold the two spoon pieces on top of each other and tack weld them together at the back.

Clamp the four forks at the handle base position and bend them backwards to 90 degrees.

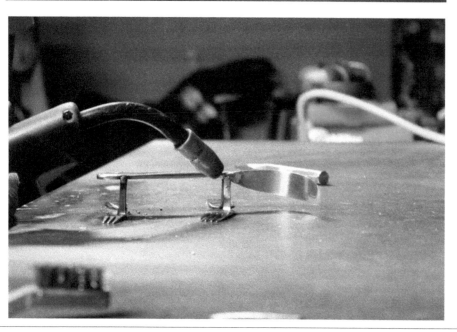

Stand the four legs up all slightly angled forward and hold the body over them. Tack weld each leg in place using at least one tack weld on either side of the leg.

Flip the lizard upside down and hang the neck off the bench. Holding the head upside down push it against the neck and tack weld it in at least two places.

Clean any weld discoloration with a wire brush and chip any spatter with a hammer and chisel.

Beetle

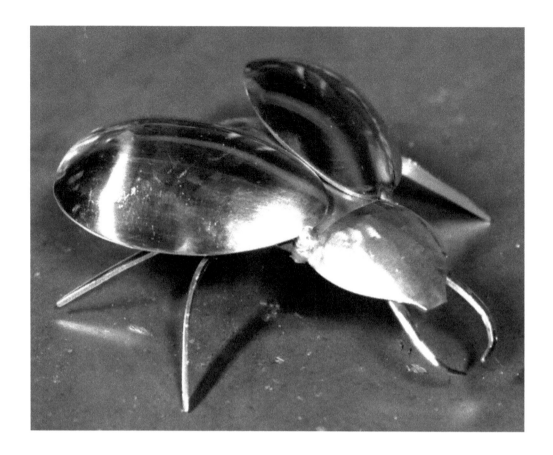

Difficulty Level

🍴 🍴 🍴

Materials:
- 3 large spoons
- 1 small spoon
- 2 forks

Tools:
- Vise
- Grinder with a cutoff wheel and sanding disk
- Hammer
- Chisel
- Marker
- Wire brush

Mark and cut the three large spoons at the handle base position to create the body and two wings.
Mark and cut the small spoon at the handle base position and again at the half bowl position for the head.
Mark and cut two forks at the handle base position for the legs.

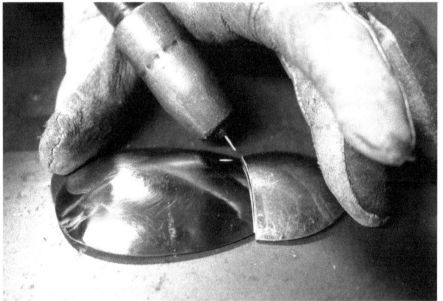

Place the head slightly over the narrow end of a whole spoon bowl and tack weld the two pieces together once on each side.

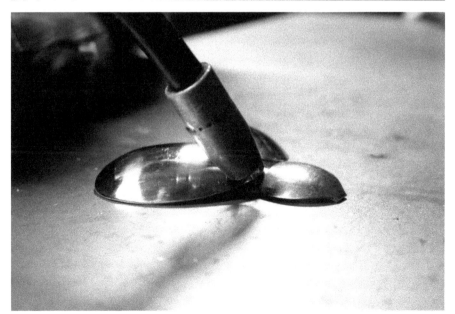

Place the narrow end of a spoon bowl up to the back of the head with the wing angled out to the side and tack weld it in position. Repeat with the other wing.

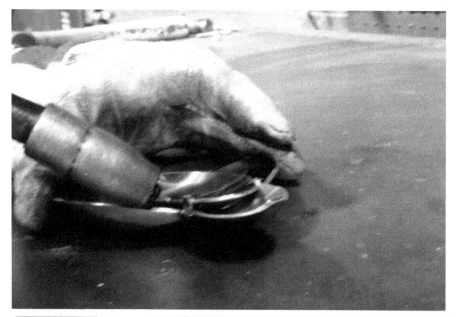

Flip the beetle upside down and tack weld the wings from the underside.

Clamp the two fork tines and pry the tines apart to give the legs a wide base.

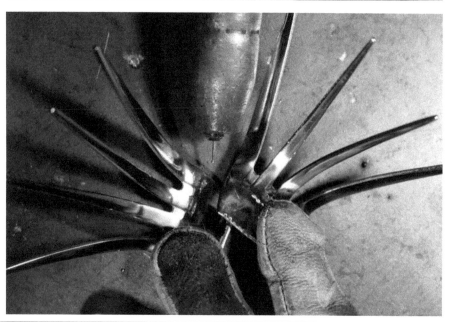

Hold the fork tines upside down at a 90-degree angle to each other and tack weld the two pieces together using small tack welds.

Clamp and cut an outside tine from each leg leaving three legs on each side and saving the two tines to be used as feelers.

Flip the beetle upside down and tack weld the legs from the bottom.

Using pliers slightly curl the legs down. Make small changes until the beetle stands flat on your work surface.

Hold and weld the two fork tine feelers underneath the beetle's head using small tack welds.
Clean any weld discoloration with a wire brush and chip any spatter with a hammer and chisel.

Penguin

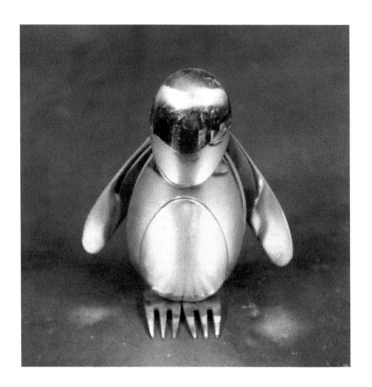

Difficulty Level

🍴 🍴 🍴

Materials:
- 2 large spoons
- 3 baby spoons
- 2 knives
- 2 baby forks

Tools:
- Vise
- Grinder with a cutoff wheel and sanding disk
- Hammer
- Pliers
- Chisel
- Marker
- Wire brush

Mark and cut the two knives at the 2/3 handle position to make flippers.
Mark and cut all spoons at the handle base position to make the body and head.
Mark and cut the two forks at the handle base position for feet.
Deburr.

Hold and tack weld the two large spoon bowls together.

Place a baby spoon bowl on top of the large spoon bowl, at the wider end of the spoons, and tack weld it on at the bottom. This piece makes up the belly.

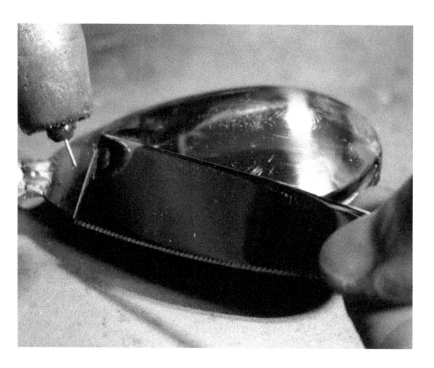

Flip the body belly side down and hold a flipper on the top of the back with the curved side of the blade facing down.
Repeat on the other side making sure the flipper is opposite.

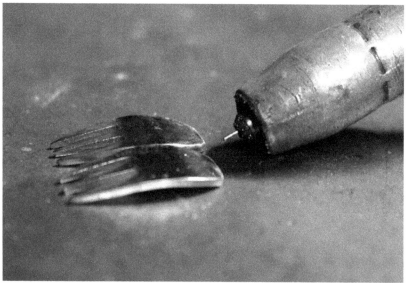

Weld the two baby forks together at the back using two small tacks.

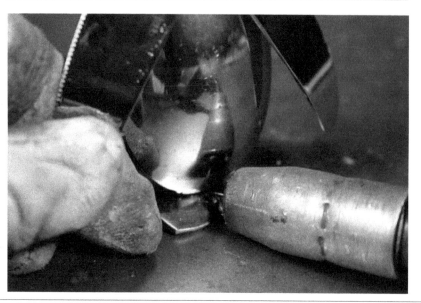

Stand the body up on the middle of the feet and lightly tack them together. Check for balance and if it's good weld the two pieces together using several small tack welds. If the balance is not good adjust and then tack weld the body to the feet.

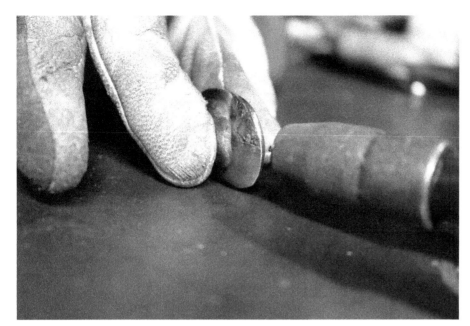

Hold and tack weld the two small baby spoon bowls together at each end to make the head.

Hold the head up to the body and tack weld them together using small tack welds.
Clean any weld discoloration with a wire brush and chip any spatter with a hammer and chisel.

Bunny

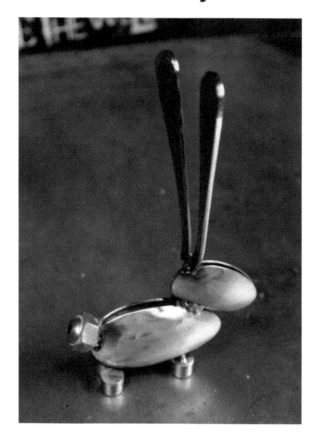

Difficulty Level

Materials:
- 2 baby spoons
- 2 large spoons
- 4 nuts or bolt heads for feet
- 1 nut and 1 bolt for a tail

Tools:
- Vise
- Grinder with a cutoff wheel and sanding disk
- Hammer
- Pliers
- Chisel
- Marker
- Wire brush

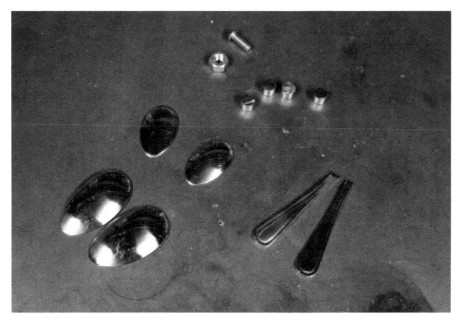

Mark and cut the four spoons at the handle base position. The two large spoons are the body, the two baby spoons are the head, and the two large spoon handles are the ears.

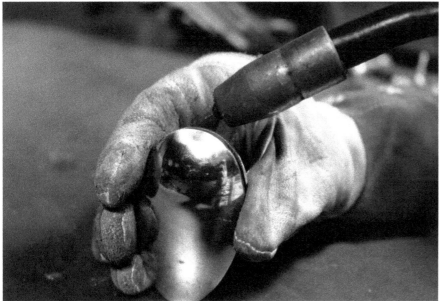

Hold and weld the two large spoon bowls together at the wider end leaving the narrower end open slightly.

Hold and weld the two baby spoon bowls together.

Hold the head into the small gap in the body with the nose angled down and tack weld the two pieces together.

Tack weld the two spoon handles in a V shape using three small tack welds at the cut end.

Hold the two feet together and tack weld them at the back. Repeat with the other set of feet.

Hold the body on top of the feet and tack weld them on using small tack welds.

Hold the ears at the back of the head and tack weld them on using small tack welds.

Tack weld the bolt into the nut by welding it in the back. Cut off any excess bolt sticking through the back of the nut.

Hold and tack weld the tail onto the south end of your bunny. Clean any weld discoloration with a wire brush and chip any spatter with a hammer and chisel.

Dog

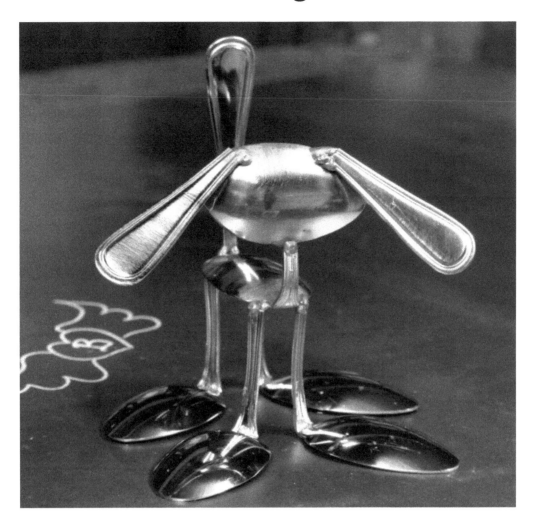

Difficulty Level:
🍴🍴🍴

Materials:
 6 Large spoons
Tools:
 Vise or clamp
 Grinder with a cutoff wheel and sanding disk
 Hammer
 Chisel
 Wire brush
 Marker

Mark and cut four spoons at the 1/2 handle position for legs. Save two handle ends for ears.

Mark and cut one spoon at the 2/3 handle position for the body and neck.

Mark and cut one spoon at the handle base for the head and tail.

Shape and deburr the cut end of the spoon bowl using your grinder.

Clamp the four leg/feet spoons and the body/neck spoon at the base of the spoon bowl and use a hammer bend the spoon 90 degrees toward the back side of the spoon.

Set the body of your dog on the bench and hold the head up to the neck positioning it where you want it. (I place my hammer on the body to hold it while welding.)
Tack the head to the neck.

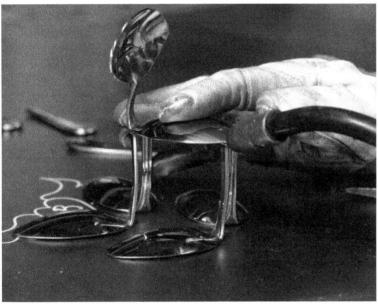

Stand the four feet/legs up on your bench. Holding the head and body over the feet/legs, tack weld each leg onto the body.

Check to see if your dog stands flat on your work surface. If needed you can bend the feet and legs slightly to keep him standing straight.

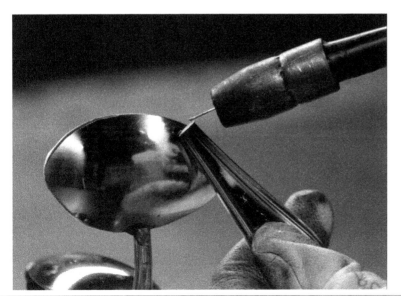

Hold each ear up to your dog's head and weld them using small tack welds.

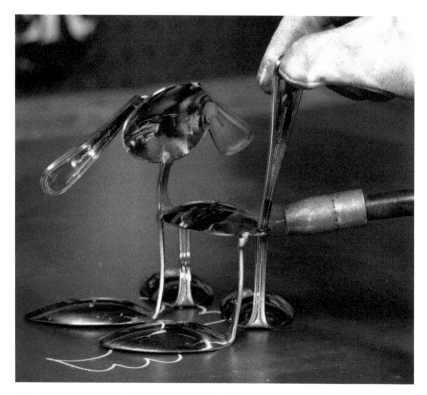

Hold the tail up to the backside of your dog's body and tack weld it on each side of the tail.

Clean any weld discoloration with a wire brush and chip any spatter with a hammer and chisel.

Cat

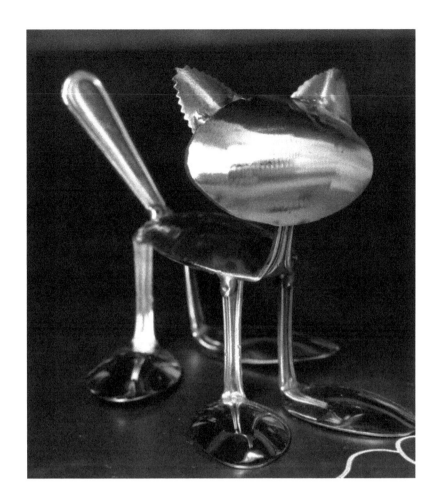

Difficulty Level

🍴 🍴 🍴

Materials:
 8 spoons

Tools:
 Vise or clamp
 Grinder with a cutoff wheel and sanding disk
 Hammer
 Chisel
 Wire brush
 Marker

Mark and cut four spoons at the 1/2 handle mark for legs.

Mark and cut one spoon at the 2/3 handle mark for the body and neck.

Mark and cut one spoon at the handle base for the head and tail.

Mark and cut two spoons 1" from the tip of the spoon bowls for ears.

Clamp and shape the spoon bowl and deburr all cut pieces.

Clamp the four feet/leg spoons and the body/neck spoon at the base of the spoon bowl and use a hammer to bend the spoon backward 90 degrees.

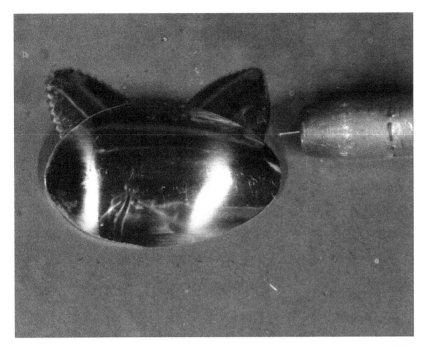

Set the head of your cat bowl side down, and place the ears in the position you would like them. Carefully weld them in place by placing a small tack on each side of the ears.

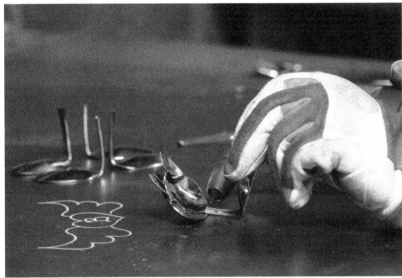

Flip the head face down on the bench and hold the neck up to it and tack weld the two pieces together, one tack on each side of the neck.

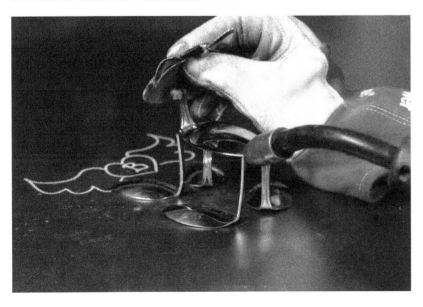

Stand the four feet/legs up on your bench. Hold the head and body over them and tack weld each leg onto the body. Adjust the leg and feet until your cat sits flat on your work surface.

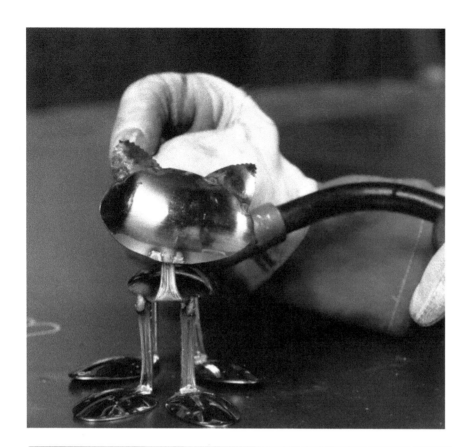

Hold the tail up to the backside of your cat's body and weld it using small tack welds on each side of the tail.

Clean any weld discoloration with a wire brush and chip any spatter with a hammer and chisel.

Mouse

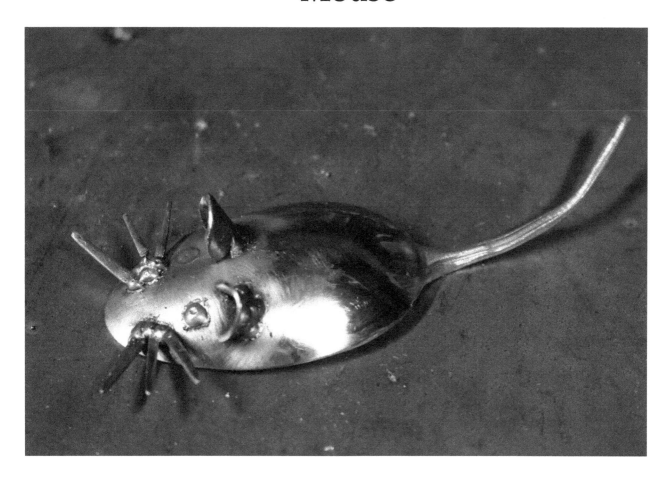

Difficulty Level

Materials:
- 3 spoons
- 2 forks

Tools:
- Vise
- Grinder with a cutoff wheel and sanding disk
- Hammer
- Chisel
- Marker
- Wire brush

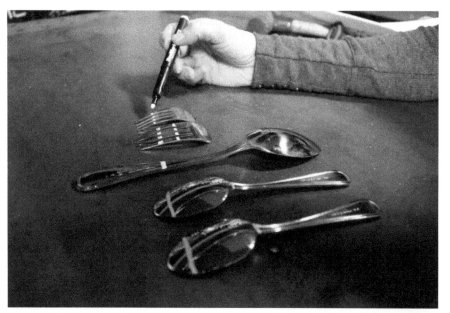

To create the body and head of your mouse take one of the spoons and mark it at the $\frac{1}{2}$ handle position and cut it.
Mark and cut two spoons 1" back from the tip of the spoon bowl to create the ears. Mark and cut the two forks 1" up the tines.

Clamp the spoon bowl body/tail and use a grinder to shape the handle into a thin tail.

Curve the tail by prying or hammering it over something round.

Clamp and squeeze the spoon tips until they curve around to look like ears.

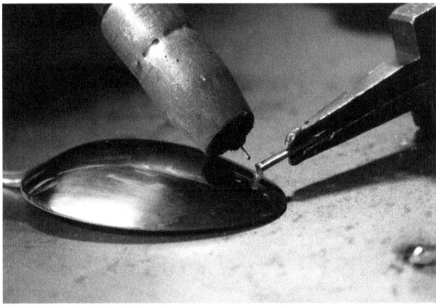

Hold and tack weld three whiskers on each side of the front of the mouse's face.

Hold and tack weld the two ears onto the mouse's face.
To give him eyes you can weld two small nuts or just weld eyes using weld.
Clean any weld discoloration with a wire brush and chip any spatter with a hammer and chisel.

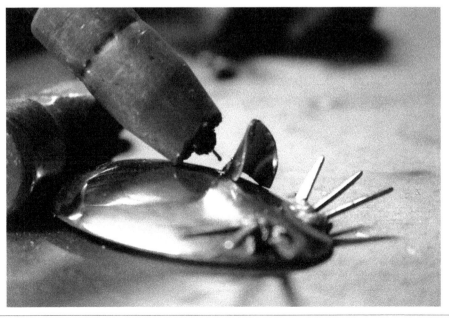

Frog

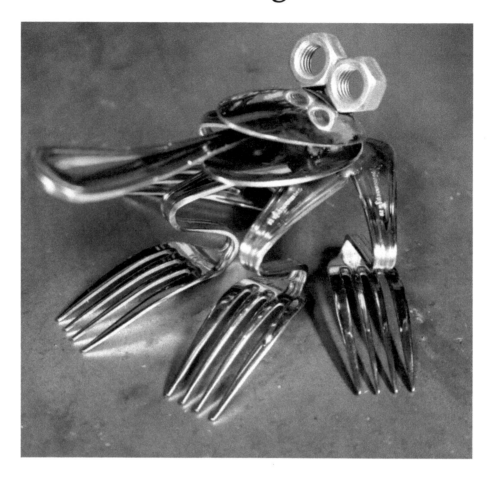

Difficulty Level

🍴🍴🍴🍴

Materials:
- 2 large spoons
- 4 forks of same size
- 2 nuts or ball bearings for eyes

Tools:
- Vise or clamp
- Grinder with a cutoff wheel and sanding disk
- Hammer
- Chisel
- Pliers
- Marker

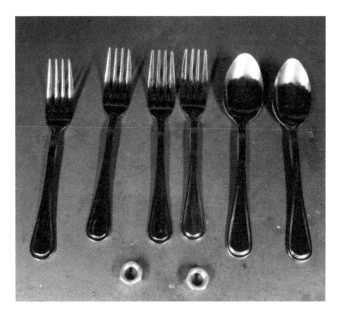

Mark and cut the spoons at the handle base position.

For consistency in bending mark the four fork handles at the handle base position and again at the 1/3 handle position.

Clamp the forks, one at a time, and bend them into a Z shape by first bending the handle 45-degrees toward the back side of the tines and then bending the top third of the handle 45-degrees in the opposite direction. Use the marks you made on the fork handles for reference.

The top of the leg should be parallel with the workbench.

Stand two legs up and angle them outward and tack weld them together at the back side.

Place the two front legs in between the two back legs making sure the handle ends butt up against each other. Tack weld the four legs together.

Weld the eyes onto the back side of a spoon bowl.

Take the spoon handle and put an S shaped curve in it by bending the cut end down and the opposite end up.

Hold the tongue on the center of the inside of the second spoon bowl and tack weld it.

Place the top half of the head on the bottom half and tack weld the two pieces together at the back using two or three small tack welds.

Hold the body on top of the legs and tack weld the two pieces together at the back. To bridge the gap between the legs and head tilt the head slightly up and tack weld a few tacks on top of each other by placing a tack weld, letting it cool slightly, and then place another tack weld on top of it. Clean any weld discoloration with a wire brush and chip any spatter with a hammer and chisel.

Peace Frog

To create a peace frog, bend the fourth leg back 90-degrees at the half handle mark, curl two of the tines down, and spread two of the tines into a peace sign. Keep in mind left hand and right hand when you go to weld this leg onto the frog. A really cool addition to this peace (pun intended) is to get a small peace charm from a local craft shop and use MIG wire to create a tiny peace necklace for my frog.

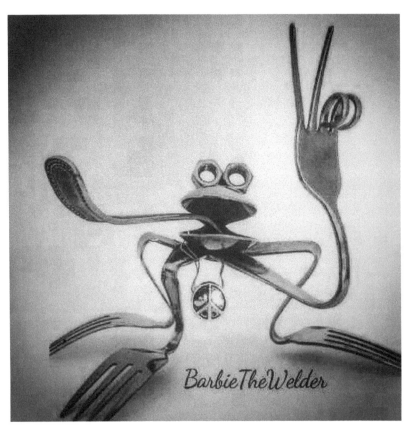

Duck

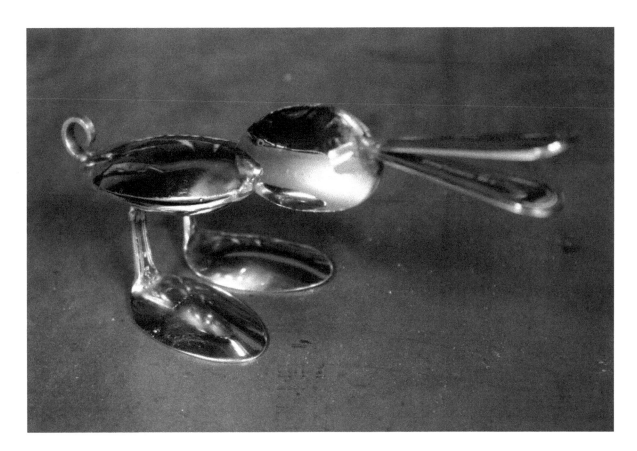

Difficulty Level

🍴🍴🍴🍴

Materials:
- 4 small spoons
- 2 large spoons
- 1 fork tine

Tools:
- Vise
- Grinder with a cutoff wheel and sanding disk
- Hammer
- Chisel
- Marker
- Wire brush
- Clear coat

Mark and cut the two large spoons at the handle base position and again 2" down the handle to create the body and beak.
Mark and cut two small spoons 1.5" up from the handle base position to create the feet/legs.
Mark and cut two small spoons at the handle base position to create the head.

Clamp and bend the feet/legs at the handle base position to 90-degrees.

Hold the two small spoon bowls together, back side of the spoon out, and tack weld them together once on each end.

Hold the two spoon handle ends together at the skinny end and hold the wider end apart 1" and tack weld the skinny end using small tack welds.

Hold the head using pliers or vise grips and tack weld the beak to the front center of the head using small tack welds on top and bottom.

Hold the two large spoon bowls together, back side of the spoon out, and tack weld them using small tack welds at each end.

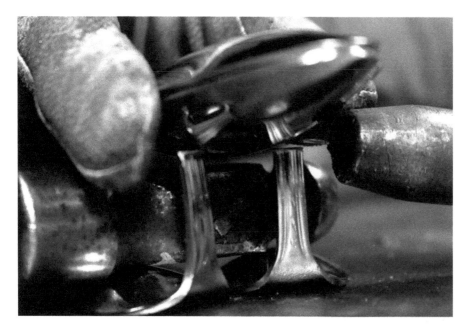

Center the body over the two feet/legs and lightly tack weld them using small tack welds on each side of the leg where it touches the body. Check for balance and adjust if necessary.

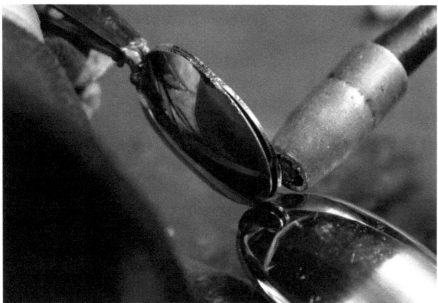

Hold the head up to the body and tack weld them together using small tack welds on each side of the head.

Hold the fork tine up to the duck's rear end and tack weld it using small welds.

Hold the tip of the tail with a pair of pliers and curl it forward.

Clean any weld discoloration with a wire brush and chip any spatter with a hammer and chisel.

Turkey

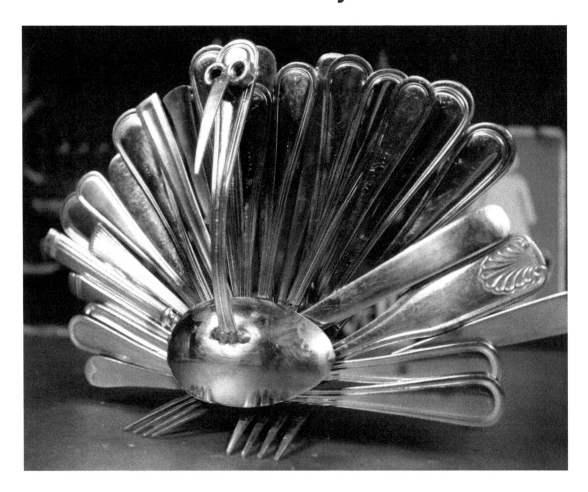

Difficulty Level

Materials:
- 21 large spoons
- 3 forks
- 2 eyes

Tools:
- Vise or clamp
- Grinder with a cutoff wheel and sanding disk
- Marker
- Wire brush
- Hammer
- Chisel

Mark and cut all the silverware at the handle base position. (If you have been saving pieces from other projects the turkey is a perfect project for them.)

Mark and cut one tine from one of the forks.

Save one handle aside for the neck and then spread the remaining handles out to create the fan.

Tack weld each handle to the other handles.

Tack weld the two fork tine pieces together.

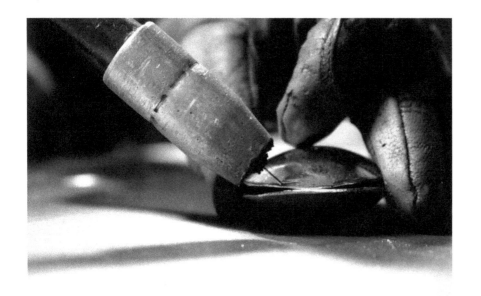

Hold the two spoon bowls and tack weld them once at each end.

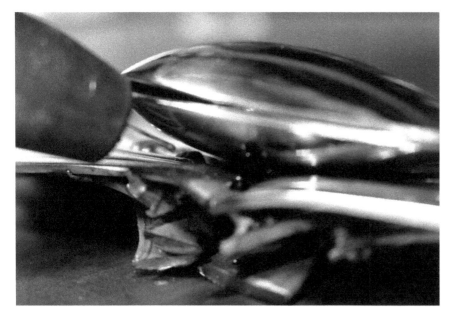

Place the spoon bowl body on top of the fan and tack weld them in at least two places.

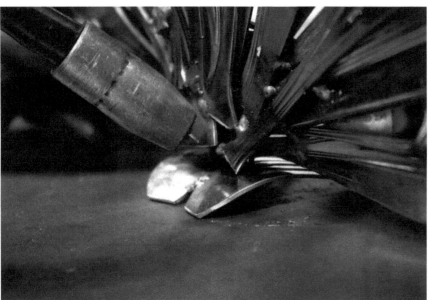

Stand the fan up centered on the fork tine feet and tack weld the feet to the fan using a small tack weld. Check the balance. Adjust as necessary. Once your turkey stands on his own weld three more tacks to securely connect the fan to the feet.

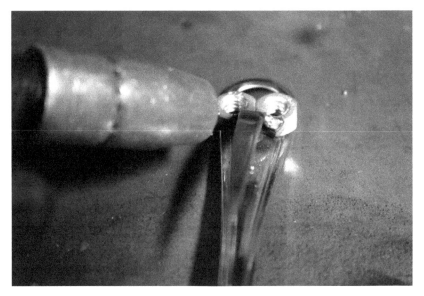

Weld two eyes and a fork tine beak to the top of the remaining handle.

Curve the neck.

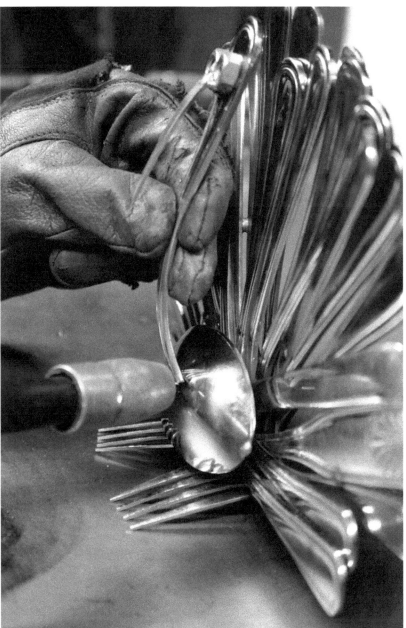

Tack weld the neck to the body.

Clean any weld discoloration with a wire brush and chip any spatter with a hammer and chisel.

Goat

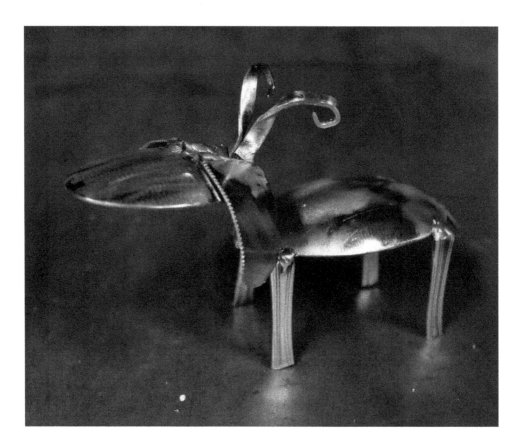

Difficulty Level

🍴🍴🍴🍴

Materials:
 4 small spoons
 1 large spoon
 2 knives
 1 fork

Tools:
 Vise
 Grinder with a cutoff wheel and sanding disk
 Hammer
 Chisel
 Marker
 Wire brush
 Clear coat

Mark and cut the four small spoons at the handle base position and again at the half handle position.

Cut the two outside tines from the fork for the horns and an inside tine for the tail.

Cut the large spoon at the handle base position and again 1" up the handle. The spoon bowl is the body and the 1" piece is the neck.

Mark and cut the two knives 2" down the blade. These are the ears.

Clamp the fork tines, one at a time, and curve the ends over using pliers.

Curve the knife ends by squeezing them with the vise. Make sure to hold the piece as you squeeze it so it doesn't fly out and get ya!

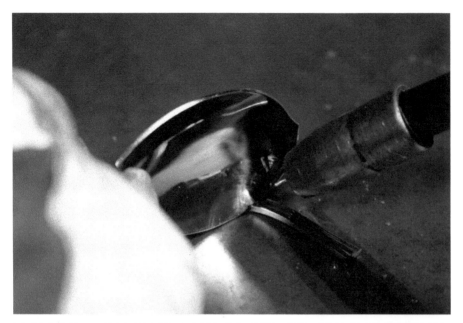

Hold the large spoon bowl on its side and place a leg up to it and tack weld it in place.

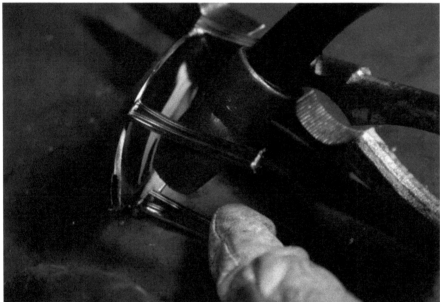

Hold and tack weld the remaining three legs in place.

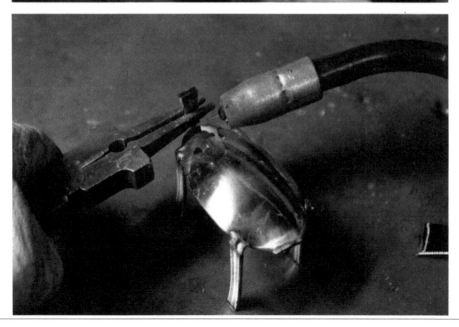

Stand the body up and hold the 1" neck piece up to the front and tack weld it to the body. If the body doesn't stand flat use a grinder to slightly shorten any leg that is longer.

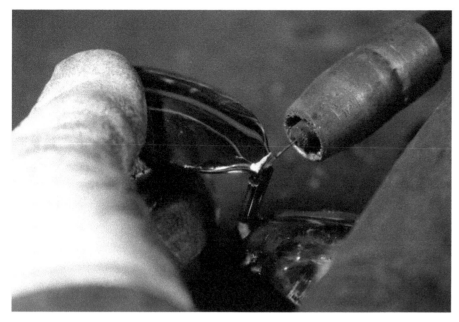

Hold the small spoon bowl up to the neck and tack weld it on.

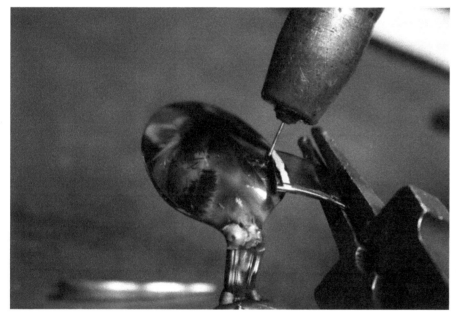

Hold an ear, curved knife piece, up to the head and tack weld it in place. Repeat with the other ear.

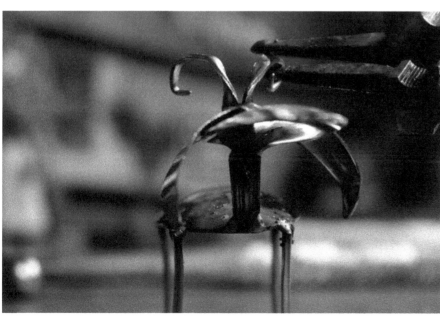

Use two fork tines to create horns and another for a tail. Shape the horns and tack weld on.
Tack weld the tail on. Use a wire brush to clean any weld discoloration and a hammer and chisel to chip any spatter.

Bird

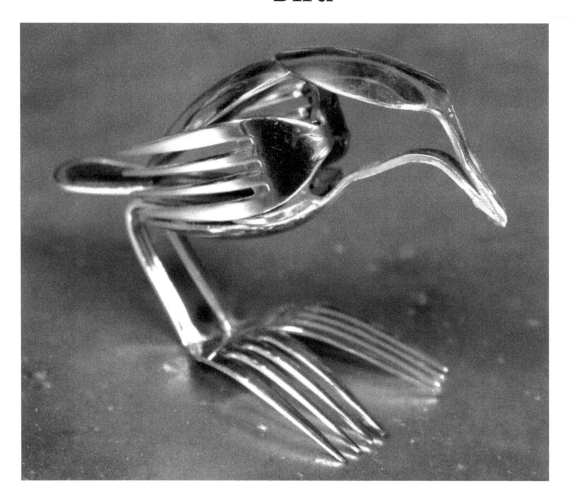

Difficulty Level

Materials:
- 2 large spoons
- 1 small spoon
- 4 forks

Tools:
- Vise
- Grinder with a cutoff wheel and sanding disk
- Hammer
- Chisel
- Marker
- Wire brush

Mark and cut one large spoon at the half handle position.
Mark and cut the small spoon 1.5" up from the handle base position.
Mark and cut two forks 1/2' up from the handle base position.

Bend the whole large spoon 90-degrees at the handle base position and bend it again 1.5"

Bend the two whole forks 45-degrees at the handle base position

Clamp the forks at the half handle position and bend them until the top half of the spoon handle is parallel with the fork tines. Repeat with the second fork.

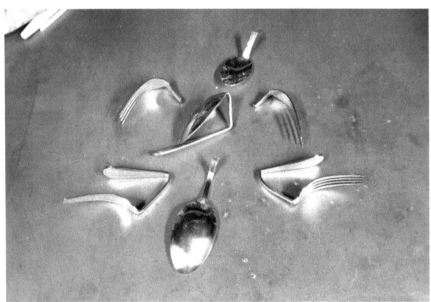

Pieces bent and ready to weld.

Place the fork legs together with the feet slightly angling out. Tack weld them together where the handles touch in at least two places.

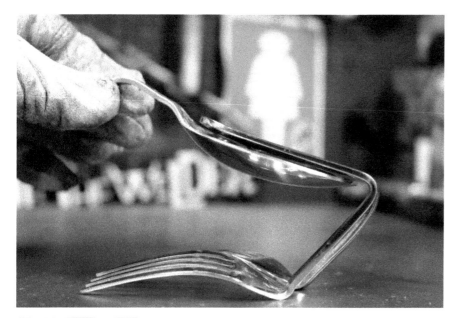

Hold the large spoon that was cut at the half handle position up underneath the legs and tack weld the spoon bowl to the legs.

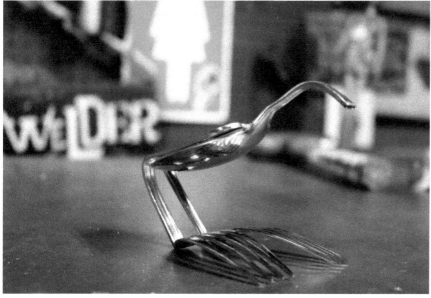

Bottom of the body, neck, and beak tack welded to the legs.

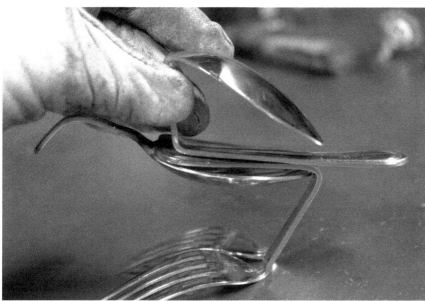

Hold the large spoon bowl that was bent into a triangle shape on top of the legs and tack weld it in place. This piece creates the tail feathers, neck and back of the bird.

Hold one set of fork tines up to the neck and tack weld them on to create feathers. Repeat with the other side.

Hold the small spoon up to the large spoon and tack weld the two together to create the top of the head and beak.

Grind and smooth the beak to give it a pointed shape.

Clean any weld discoloration with a wire brush and chip any spatter with a hammer and chisel.

Butterfly

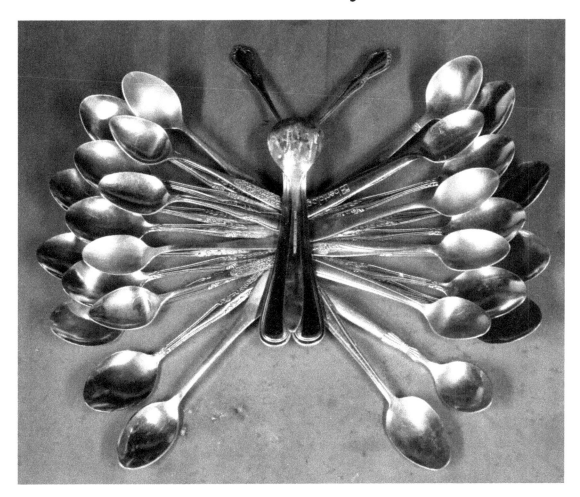

Difficulty Level

🍴🍴🍴🍴

Materials:
 32 spoons

Tools:
 Vise or clamp
 Grinder with a cutoff wheel and sanding disk
 Hammer
 Chisel
 Marker
 Wire brush

Mark and cut four spoons at the handle base position.

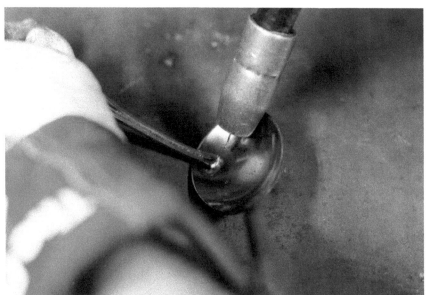

Tack weld two spoon handles into the spoon bowl at the 1 o'clock and 11 o'clock positions.

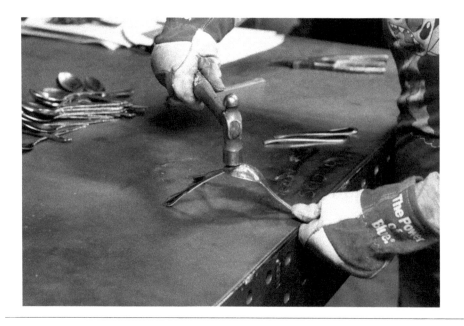

Hammer the spoon bowl/antennas flat.

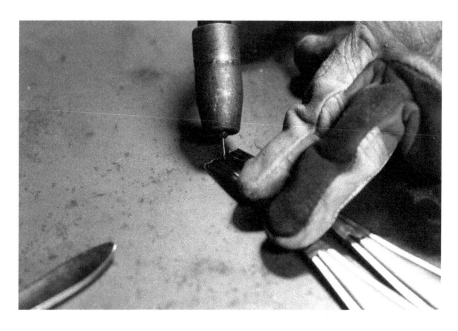

Hold two spoon handles side by side and tack weld them together at the cut ends.

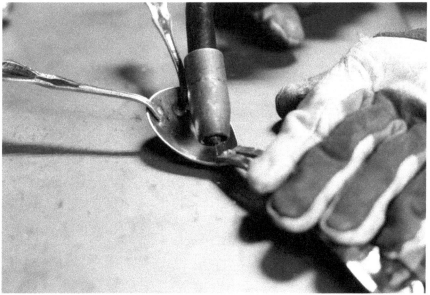

Hammer the spoon handle cut end top 1/2" forward slightly and then lay them on back of the spoon bowl head and tack weld them on in at least two places.

Separate the remaining spoons into two piles. If you have smaller and larger spoons keep the two piles as even as possible.

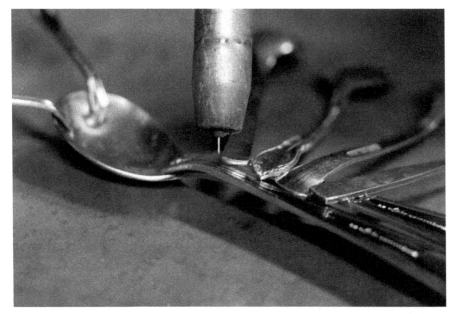

Place the body upside down and lay out four spoons on the right side, handles touching, and spoon bowl end slightly fanned out. Tack weld each one to the body in at least two places.

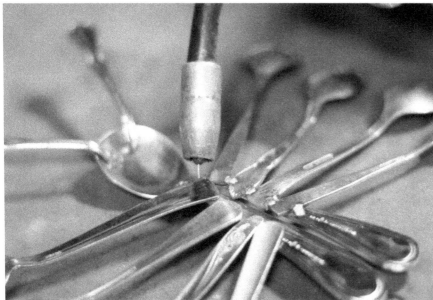

Place and tack weld four spoons on the left side.

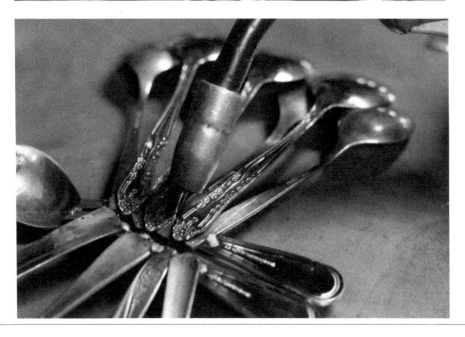

Center and tack weld three spoons on top of the first four on the right side and again on the left side.

Move the third layer out 1" and tack weld four spoons on top of the previous layer.

Repeat on the left side.

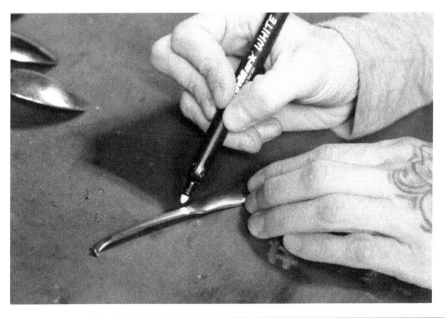

Create a hanger for your butterfly by using a left over handle piece from a previous project mark and cut a 3" piece.

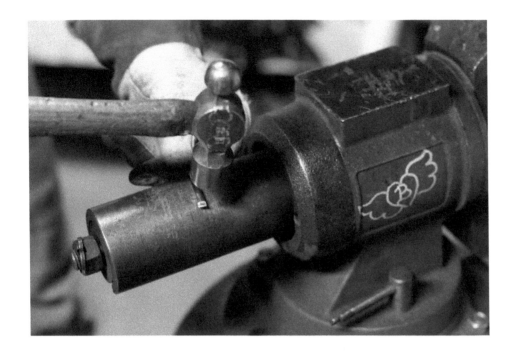

Hammer a curve into it.

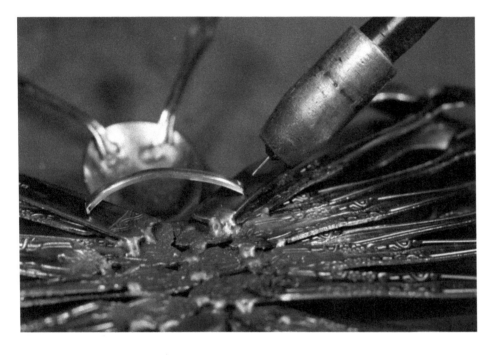

Tack weld it onto the back of the butterfly.

Clean any weld discoloration with a wire brush and chip any spatter with a hammer and chisel.

Deer

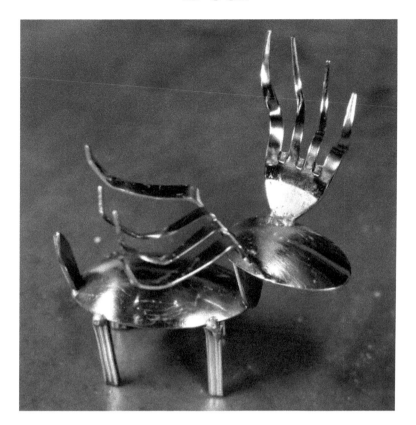

Difficulty Level

Materials:
- 1 large spoon
- 1 small spoon
- 2 forks

Tools:
- Vise or clamp
- Grinder with a cutoff wheel and sanding disk
- Pliers
- Hammer
- Chisel
- Marker
- Wire brush

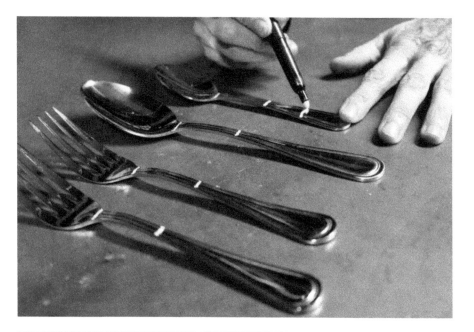

Mark and cut all the silverware at the handle base position and the 2/3 handle position to create the legs, body, head, and antlers. Mark and cut the small spoon handle at the 1/3 handle position to make the neck and tail.

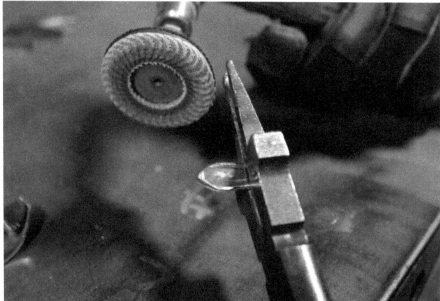

Deburr all cut pieces.

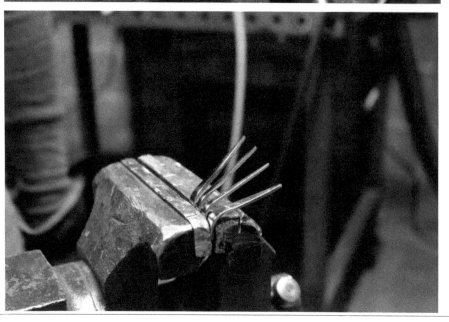

Clamp the fork tines at the base and hammer them backwards so that one is almost to 90-degrees, the one behind it is not bent as far, the one behind that is bent less, and the last one is bent slightly.

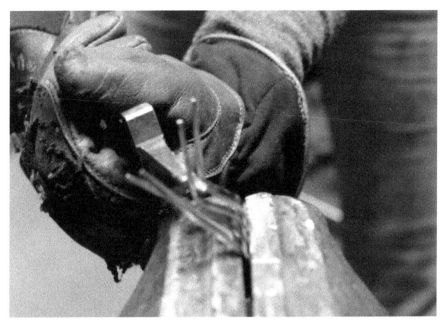

Use pliers to bend each tine up.

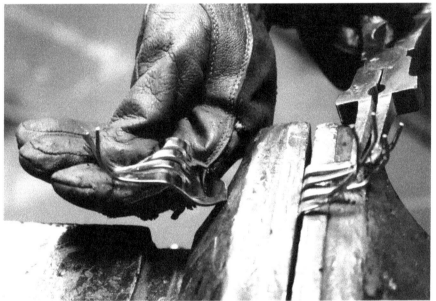

Repeat with the other set of tines making sure you bend them opposite from the first side.

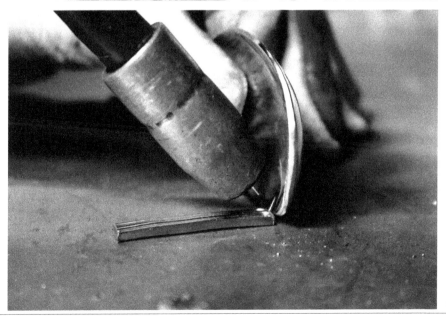

Hold the larger spoon on its edge and place a leg up to the back and tack weld it on.

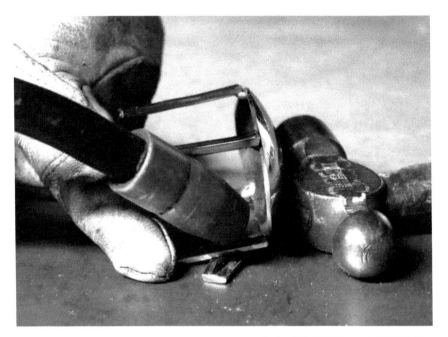

Tack weld the remailing three legs on.
If he wont stand flat use a grinder to slightly shorten any leg that is longer.

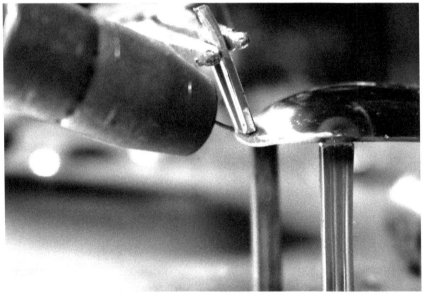

Hold and tack weld the tail on to the deer's backside.

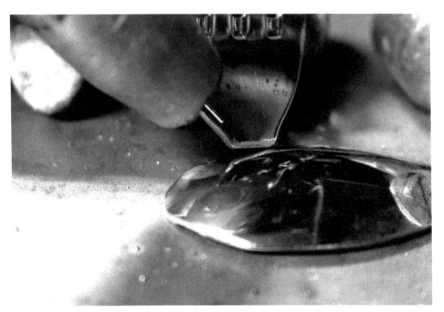

Hold a set of antlers on the back left side of the small spoon bowl and tack weld them on.
Hold and tack weld the right side antlers in place.

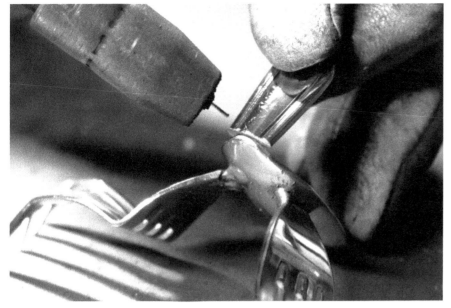

Flip the head upside down and hold the neck up to the back of the head and tack weld it in place.

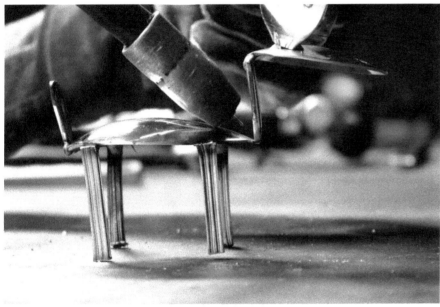

Hold the neck up to the front of the body and tack weld it in place.

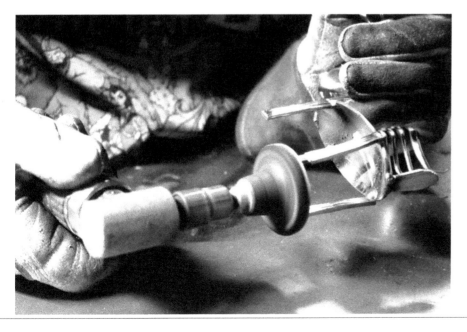

Clean any weld discoloration with a wire brush and chip any spatter with a hammer and chisel.

Elephant

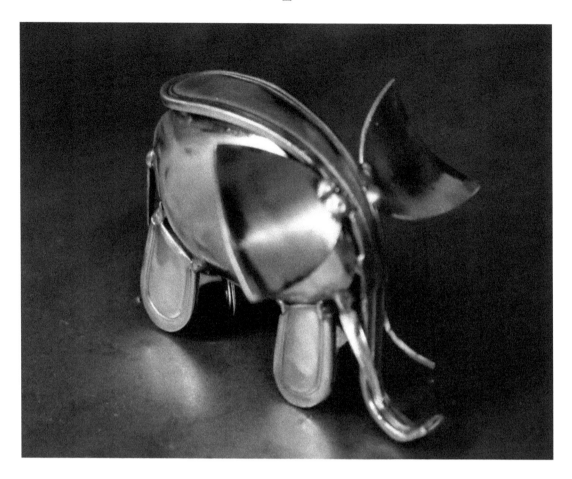

Difficulty Level
🍴🍴🍴🍴

Materials:
- 2 large spoons
- 2 small spoons
- 1 fork

Tools:
- Vise or clamp
- Grinder with a cutoff wheel and sanding disk
- Marker
- Hammer
- Chisel

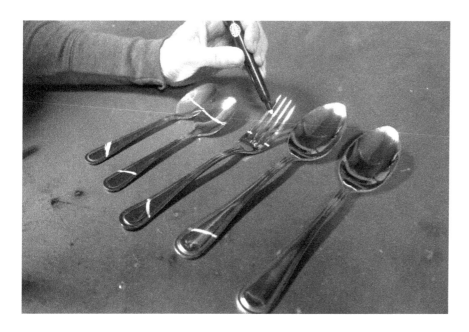

Mark and cut the two large spoons at the handle base position for the body.
Mark and cut three fork tines for the tusks and tail.
Mark and cut the two small spoons at the half bowl position for ears.
Mark and cut four handles at a 45-degree angle 1" from the handle end for legs.

Place a spoon bowl on the bench and tack weld the legs to the bottom. Prop the top slightly to angle the legs.. Repeat with other spoon bowl and leg pieces.

Stand the two halves up and tack weld them together front and back.

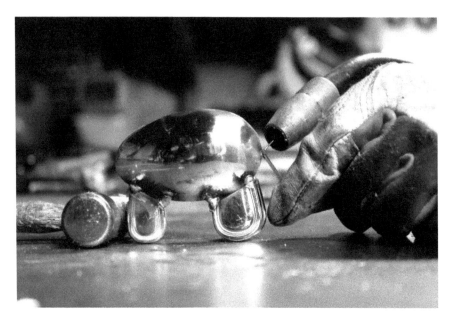

Hold and tack weld the trunk on.

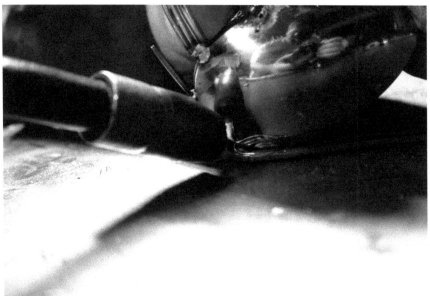

Place the whole handle upside down and the body upside down on it with the thicker end of the handle at the base of his tail and tack weld it to the body once on each side.

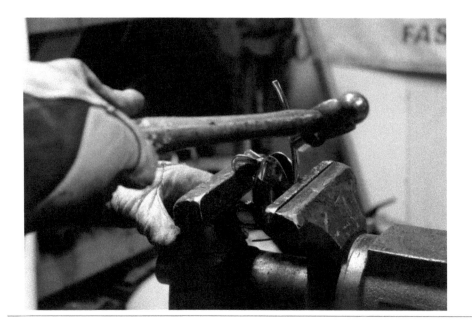

Clamp the piece and continue to curve the handle down over the front of the elephant's body.

Pull the handle down to match the curve of the elephant's back and tack weld it in place on each side.

Using whatever means necessary bend the trunk up into the position you like.

Hold the tusk with a pair of pliers and tack weld one on. Repeat with the other side.

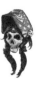

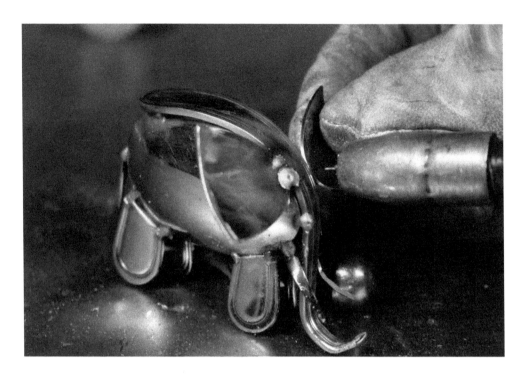

Hold and tack weld each ear on.

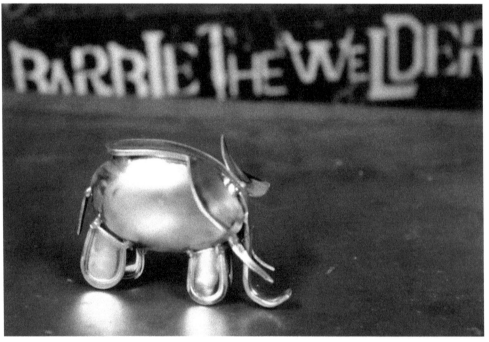

Clean any weld discoloration with a wire brush and chip any spatter with a hammer and chisel.

Ant

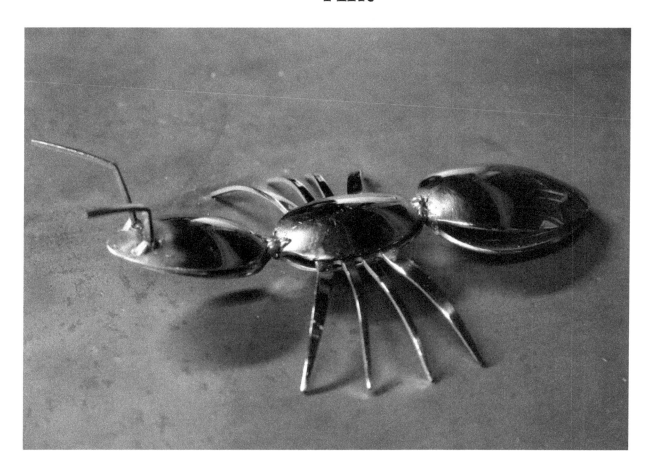

Difficulty Level

Materials:
- 2 large spoons
- 4 small spoons
- 3 forks

Tools:
- Vise
- Grinder with a cutoff wheel and sanding disk
- Hammer
- Chisel
- Marker
- Wire brush

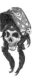

Mark and cut the six spoons and two of the forks at the handle base position. Mark and cut the two outside tines off the remaining fork

Overlap one set of fork tines 1/2' onto the other set of fork tines and tack weld the two together to create legs.

Clamp the fork tine legs and separate the tines.

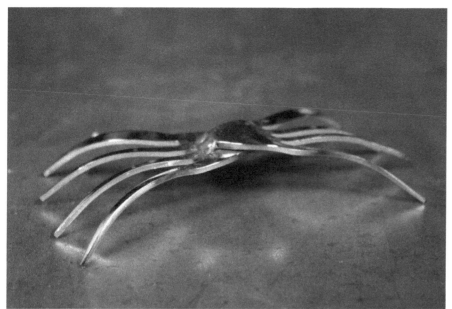

Hammer or push the legs down until the center is one inch off the bench

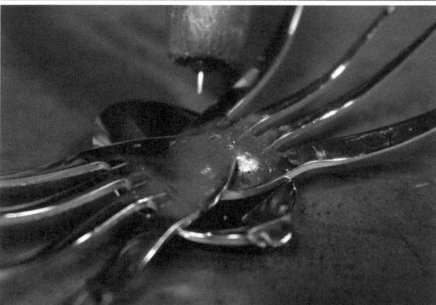

Place a small spoon bowl down and set the legs upside down on top of them. Tack weld the legs to the bowl on each side front and back.

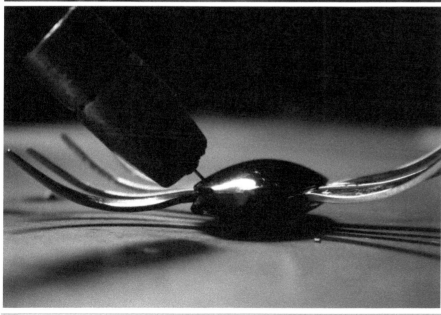

Place a small spoon bowl on top of the first spoon bowl and tack weld the two pieces together at one end.

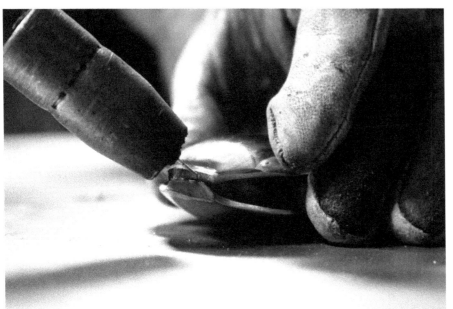

Hold the other two small spoon bowls together, back side of the bowls out, and tack weld them together at one end using small tacks. This is your ant's head

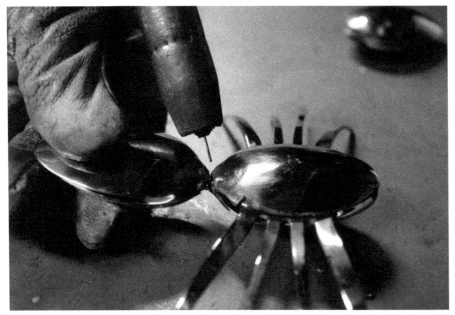

Flip the leg section up right and hold the head up to it and tack weld the two pieces together.

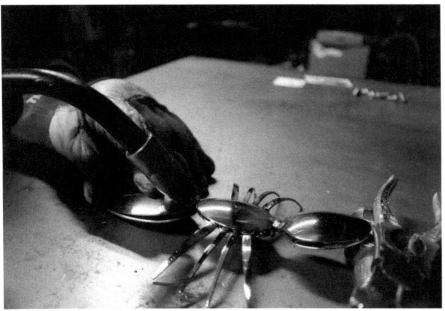

Tack weld the two large spoon bowls together, back side of the bowl out. This is the rear end of your ant. Hold rear end up to the body and tack weld it in place using small tack welds.

Clamp a fork tine and bend it slightly. Repeat with the second tine. These are your feelers.

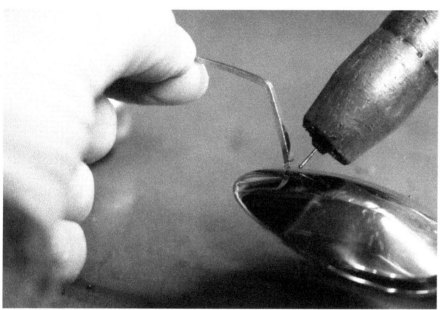

Hold the feeler up to the front of your ant's head and weld it using small tacks. Repeat with the other feeler.

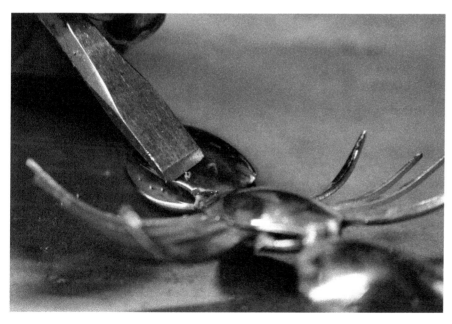

Use a wire brush to clean any weld discoloration and a hammer and chisel to chip any spatter.

Giraffe

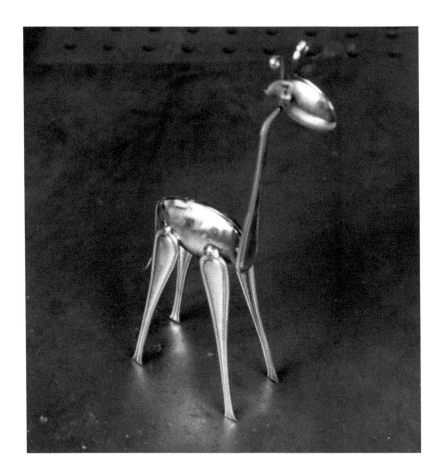

Difficulty Level

🍴🍴🍴🍴🍴

Materials:
- 4 large spoons
- 2 baby spoons
- 1 large fork
- 1 baby fork

Tools:
- Vise or clamp
- Grinder with a cutoff wheel and sanding disk
- Hammer
- Chisel
- Marker
- Wire brush

Mark and cut the four large spoons at the handle base position.
Mark and cut the baby spoons at the half handle and the handle base position
Mark and cut the baby fork at the half handle position.
Deburr all pieces.

Mark and cut the large fork at the handle base position, the tine base position, and mark a small curving line from the center of the tines out to the left and right of the handle base position like pictured,
Keep the two small triangles for ears, two of the tines and the fork handle.
Shape the ears using a small grinder.

Hold the two large spoon bowls with one side touching and the opposite side apart 3/4" and place two tack welds on the back.

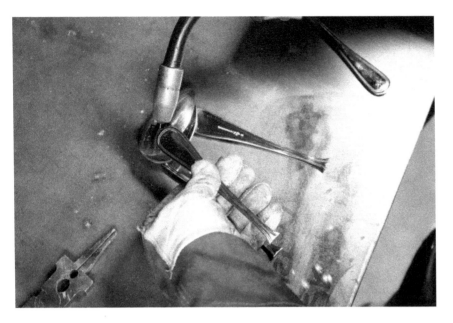

Lay the body on its side horizontally with the open side facing you. One at a time hold the wider end of the spoon handles on the side of the body making sure to angle them up and slightly back to give your giraffe a wide base, and tack weld them on. Stand your giraffe up and adjust the stance by spreading the legs out further or pulling them in or by grinding length off of a leg until it stands flat.

Hold the two baby spoon bowls, back side of the bowls out, and tack weld them together.

Gently hold the head with vise grips. Hold a triangle to the back side of the head using needle nose pliers and carefully tack weld the top and bottom. Repeat with the other ear.

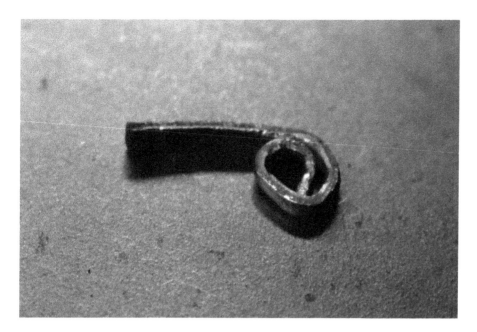

Clamp the two fork tines in your vise one at a time and curl the top half around using a pair of needle nose pliers to create the giraffe's horns or ossicones. (I Googled that!)

Hold the ossicones with pliers and tack weld one on each side behind the ears.

Hold and weld the neck on the front.

Curve the top 1" of the neck slightly forward. Hold and weld the head onto the neck.

Hold the tail up to the giraffe's hind end and gently weld it on.

Clean any weld discoloration with a wire brush and chip any spatter with a hammer and chisel.

Goose

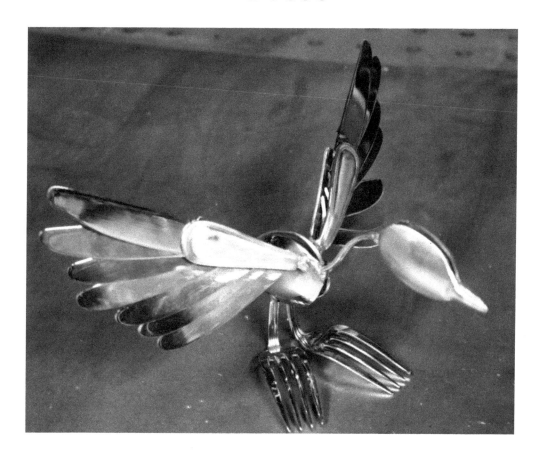

Difficulty Level
🍴🍴🍴🍴🍴

Materials:
 2 large spoons
 2 small spoons
 2 forks
 12 knives

Tools:
 Vise
 Grinder with a cutoff wheel and sanding disk
 Hammer
 Chisel
 Marker
 Wire brush

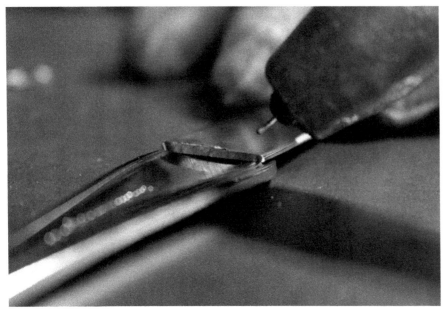

Mark and cut two forks 1.5" up from the handle base position to create the feet/legs. Mark and cut one small spoon at the 1/3, 2/3, and handle base position to create half the head and the beak. Mark and cut one small spoon at the 1/3 handle position and the handle base position to create half the head and the neck. Mark and cut the two large spoons at the handle base positions to create the two halves of the body and the main structure of the wings.

Mark and cut the knives at the 2/3 blade position.

To create the wings take the two large spoon handle pieces and mark the back of them exactly in the middle as a reference point. Place one handle on the left and one on

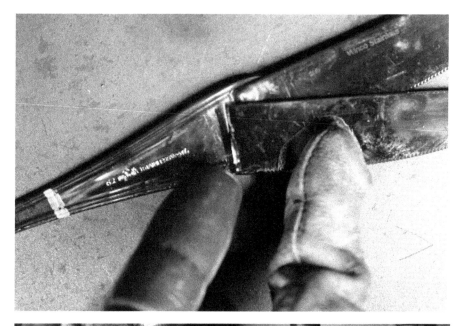

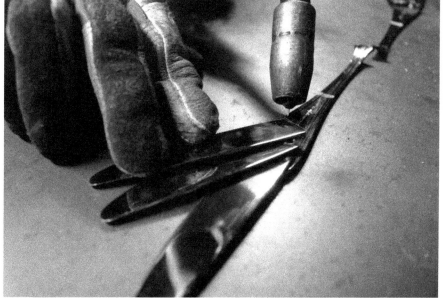

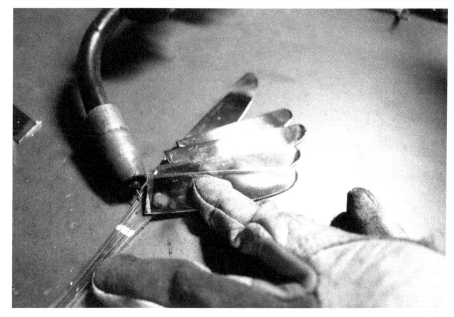

the right. What you do to the left you do the same to the right only mirrored.

Place one knife blade on the end of the right spoon handle overlapping 1/2" with the curved side of the blade down and tack weld it in place. Repeat on the left side making sure to position the curved side of the blade down.

Place a second knife on the righthand wing with the blade overlapping the first, slightly over to the left (top picture) and angled down slightly from the first, and tack weld it in place. Repeat this step on the other wing.

Using six knife blades per wing continue moving inward towards the center line on the wing angling each feather down as you go until you reach the center line on the handle.

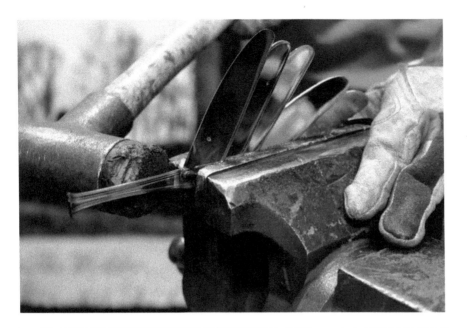

Clamp each wing at the mark you made and hammer the remaining half handle over folding it until it covers where you welded the feathers on.

One wing welded with the piece bent over the welded feathers.

Hold the two small spoon bowls together, back side of the bowls out, and tack weld them on each end.

Take the two small 1/3 handle cut pieces and tack weld them on the front on the two spoon bowls.
Weld down each side using small tack welds.

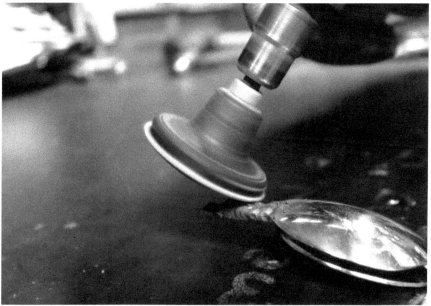

Grind and smooth the beak to make it look like one solid piece. Hammer it straight if yours turned our crooked like mine!

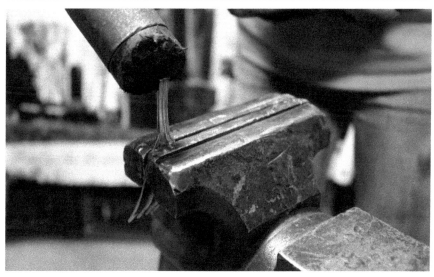

Clamp the two fork feet/legs at the handle base position and hammer the handles over towards the back side of the forks 90-degrees.

Hold and tack weld the two large spoon bowls together using two small tack welds one on each end.

Set the two feet/legs down and hold the body over the legs with the front tilted up at 45-degrees.

Hold one wing up to the center of the body and tack weld it on with a light tack. Repeat with the other wing. If it balances finish welding each wing on. If it doesn't balance make small adjustments until it does.

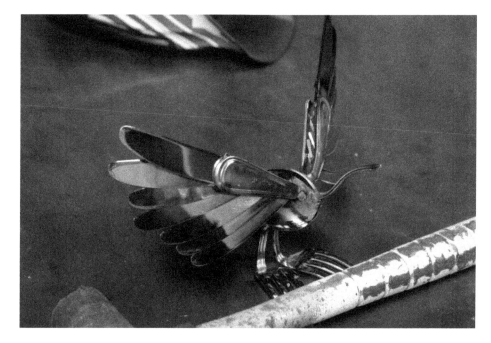

Curve the small spoon handle into an S shape using a hammer and a rounded surface. Tack weld the neck onto the front of the body.

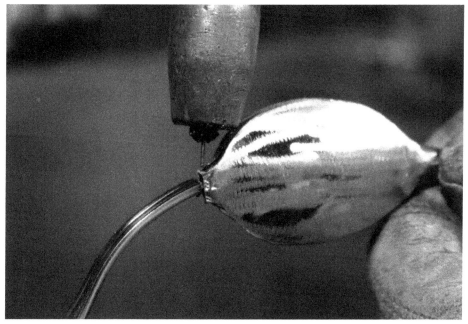

Tack weld the head onto the neck using small tack welds on both sides.
Use a wire brush to clean any weld spatter and a hammer and chisel to chip any spatter.

Spider

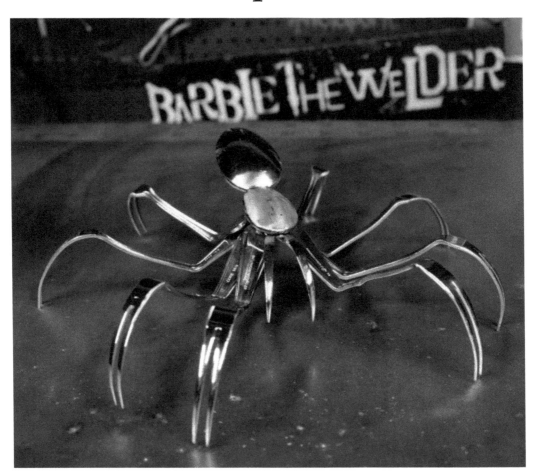

Difficulty Level

🍴🍴🍴🍴🍴

Materials:
- 8 forks
- 2 large spoons
- 2 small spoons

Tools:
- Vise or clamp
- Grinder with a cutoff wheel and sanding disk
- Hammer
- Chisel
- Marker
- Wire brush

Mark and cut the two outside tines off each fork.
Mark and cut the spoons at the handle base position.

Smooth and deburr the cut forks.

Mark the back of the forks at the 1/2 handle position for reference.

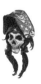

Clamp the forks one at a time and bend the tines forward until the tips are 90-degrees to the handle.

Clamp the handle ends at the 1/2 handle mark and bend the handle end backward 45 degrees.

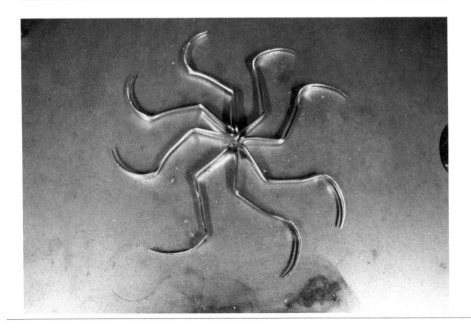

Creepy crawly spider legs.

Hold the two small spoon bowls together, back side of the bowls out, and tack weld them together.

Hold the two large spoon bowls together, back side of the bowls out, and tack weld them together.

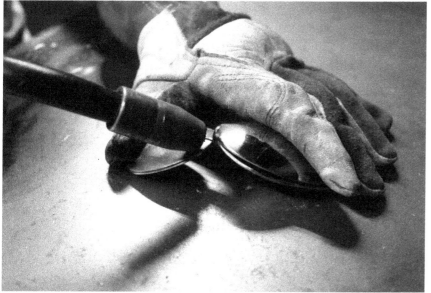

Hold the small and large welded spoons together. By squeezing them together slightly it will raise the two pieces off the bench, while they are raised up tack weld the two pieces together.

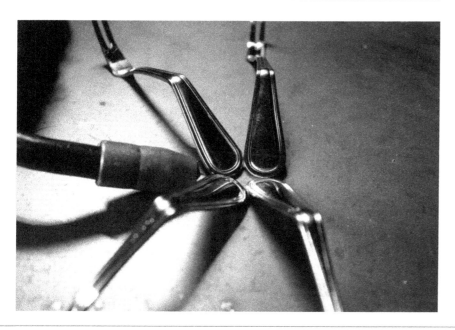

Set four legs upside down and tack weld them together like shown.

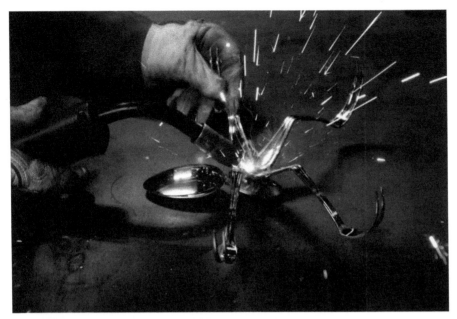

Set the four legs on top of the body, the raised side of the body up, and tack weld the legs to the smaller spoon.

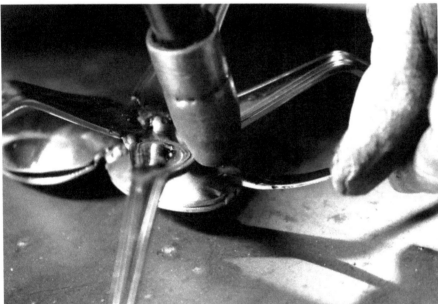

With the body still upside down tack weld one outside fork tine on either side of the front of the small spoon to create fangs.

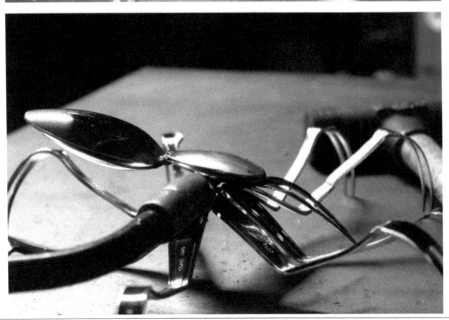

Flip the spider right side up and hold and tack weld a leg on the left side in front of the two, angled forward and then behind the two and angled backward.

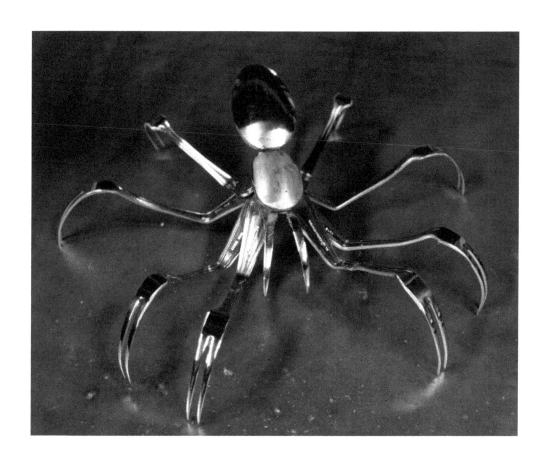

Repeat with the final two legs on the opposite side.

Clean any weld discoloration with a wire brush and chip any spatter with a hammer and chisel.

Lobster

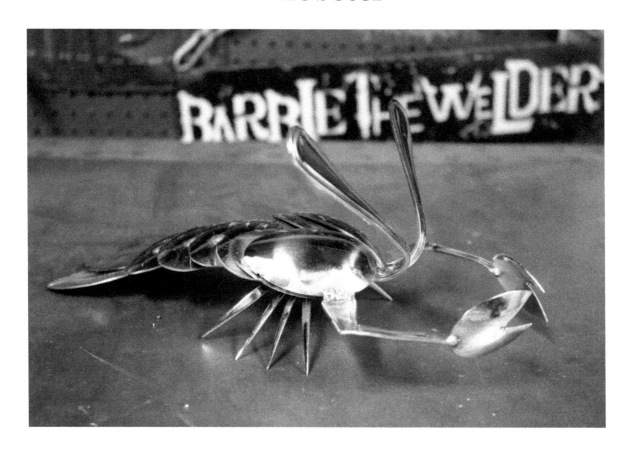

Difficulty Level
🍴🍴🍴🍴🍴

Materials:
- 12 large spoons
- 2 small spoons
- 2 large forks

Tools:
- Vise or clamp
- Grinder with a cutoff wheel and sanding disk
- Hammer
- Chisel
- Wire brush
- Marker

Flatten three large spoon bowls by holding them on a hard surface and hammering on the backside.

Mark and cut ten large spoons, including the three you flattened, at the spoon base position for shell sections. Keep two large spoons whole for antenna.

Mark and cut two small spoons at handle base and again at the half handle position for the claws.

Mark and cut the two forks at the base of the handle for legs.

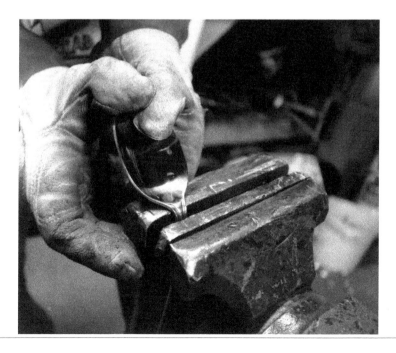

Bend the two antenna spoon handles backwards 45-degree.

135

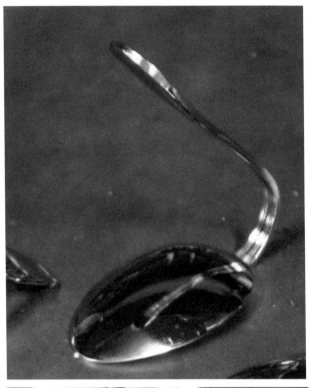

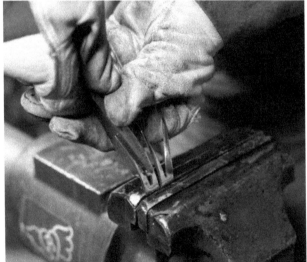

Clamp and pry the fork tines apart to create the legs.

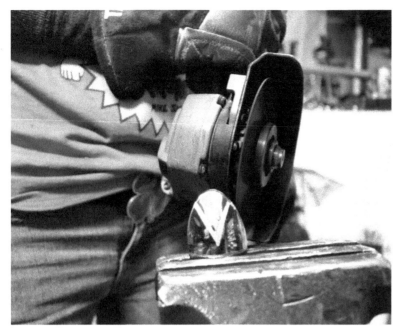

Mark and cut a V shape in the two small spoon bowls to make the claws.

Place one flattened spoon down and two more on top fanning the two top spoons out and tack weld the three pieces together.

Place one large spoon down lengthwise with the bowl facing up and set the tail on it overlapping half of the spoon bowl. Tack weld the tail to the shell piece once on each side where they touch.

Flip the weldment right side up and hold a second shell section on top of the first, overlapping it halfway, and tack weld it on the left and right side of the shell.

Repeat the same process with three more shell sections, overlapping and tacking each piece. You will have five total shell sections tack welded onto the tail section.

Hold two spoon bowls in a V shape, the wider end closer together and the narrow ends apart. Tack weld them where the two overlap.

Set the 2 spoon V section half way off the last shell section you welded on with the open end of the V facing the tail and tack weld it on with a light tack. Flip it right side up to check positioning. If you are happy with positioning tack weld the other side, if not, break the tack weld and re-tack it where you want it.

Place the body right side up and hold the two antenna/head piece overlapping the V section. The base of the handles should touch, and the back of the spoon bowls should be separated in a V similar to the previous piece. Tack weld the two together on the bottom of the handles.

Align the antenna piece to the V section. When properly aligned the antenna/head section will be 1/2 to 3/4 of an inch forward from the V section.

Tack weld both sides of the antenna/head section to the body at the back where the two pieces touch.

Flip the lobster upside down and tack weld.

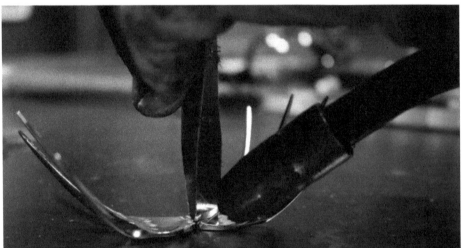

Take the two fork tine sections and hold them down on your bench, little legs up, and tack weld them together in two places.

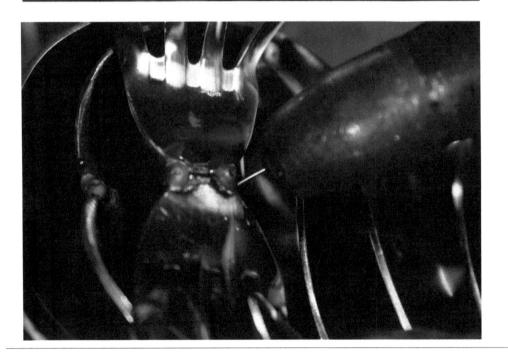

Flip the lobster upside down and hold the legs up to the body 2" back from the head and tack weld them in at least two places.

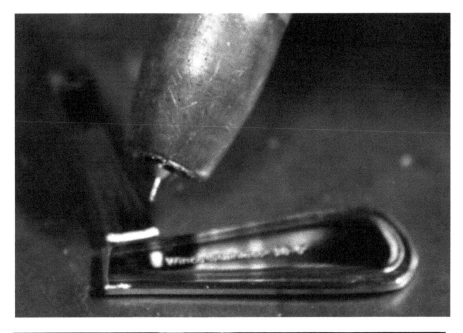

Place the two small spoon handle sections on the bench at an angle, whatever looks good to you, and tack weld them together. Repeat this step with the other two small spoon handle pieces.

Hold the claw arm (I have no clue what else to call this piece!) up to the side of your lobster slightly in front of his legs and tack weld it in place. Repeat with the other claw arm.

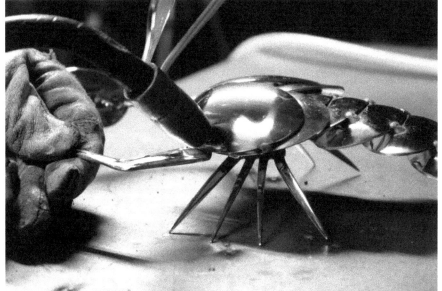

Hold and weld each claw to the claw arm.

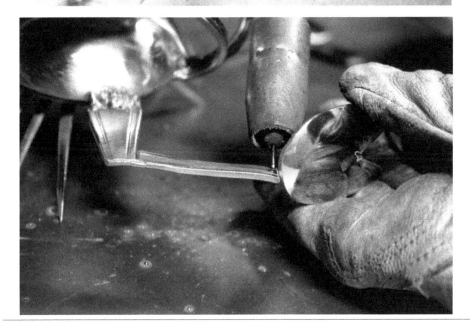

Use a wire brush to clean any weld discoloration and a hammer and chisel to chip any spatter.

Flamingo

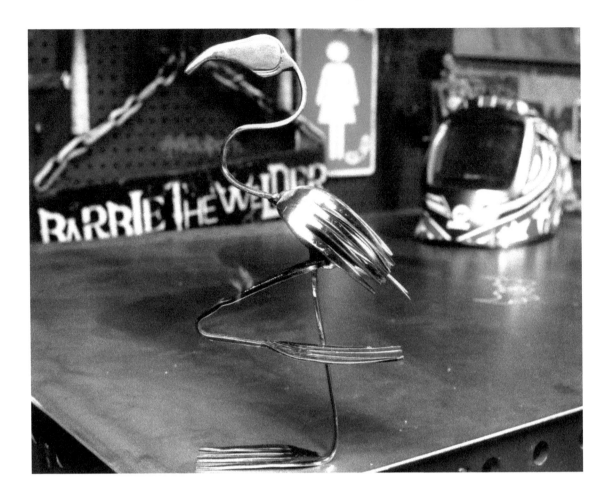

Difficulty Level
🍴🍴🍴🍴🍴

Materials:
 2 large spoons
 6 large forks

Tools:
 Vise or clamp
 Grinder with a cutoff wheel and sanding disk
 Hammer
 Chisel
 Wire brush
 Marker

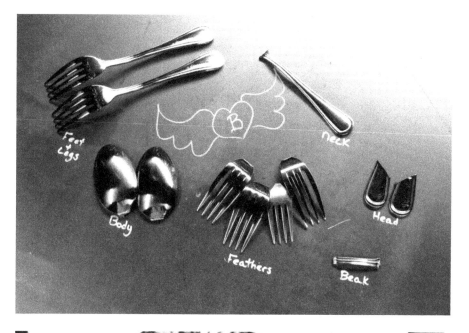

Mark and cut four forks at the handle base position keeping the four tine sections and one whole handle for the feathers and neck. Mark and cut two handles 1" from the end at a 45-degree angle for the head. Mark and cut the two spoons at the spoon base position for the body.
Mark and cut a 2' piece of thin handle for the beak.
Leave two forks whole for the legs and feet.

Take the two whole forks and hammer the tines flat.

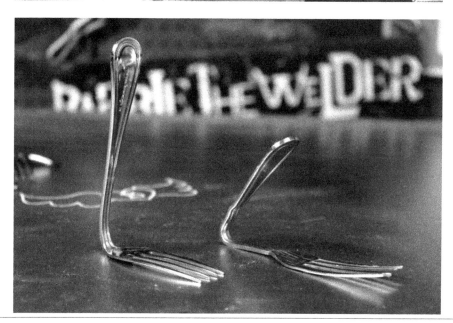

Clamp one fork at the tines and bend the leg towards the back side of the fork 90 degrees. Clamp and bend the second fork back 45 degrees.

Bend an S in the spoon handle. Some silverware you can bend by hand and others you will have to use your hammer and something round like the back of your vise, an anvil or a piece of pipe.

Take the two pieces cut into 45-degree angles, hold them together on your workbench and weld them together using small overlapping tacks.

Grind the weld smooth to look like one piece.

Mark the two pieces like I did in the picture to make a head shape. Clamp and grind the piece until you get a head shape you like.

Shape and smooth the head to make it look like it is one solid piece.

Bend the 2" handle section in half to create the beak.

Weld the beak to the head by using small tack welds around the place where the two pieces meet.

Tack weld down both sides of the beak to create one solid piece.

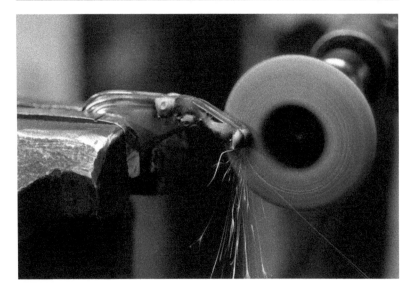

Grind and smooth the head/beak to make it one solid piece.

Flamingo head fully welded and ground smooth.

Tack weld the head to the neck in at least two spots.

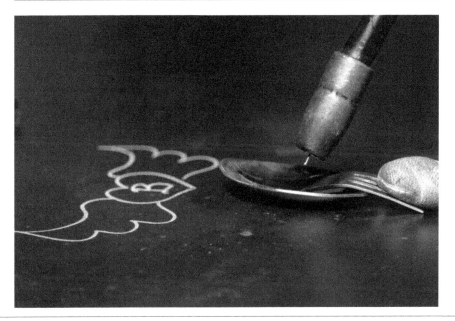

Tack weld one fork inside one spoon bowl leaving the tine end out.

Hold the second spoon bowl on top of the first and weld the two pieces together using two or three small tack welds.

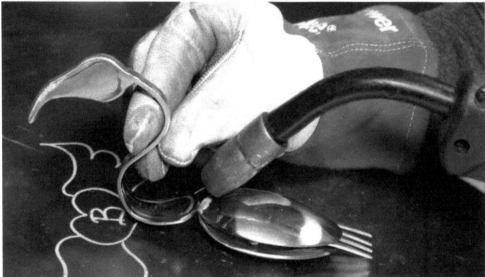

Hold the body up to the neck and weld the two pieces together using at least one tack weld on either side.

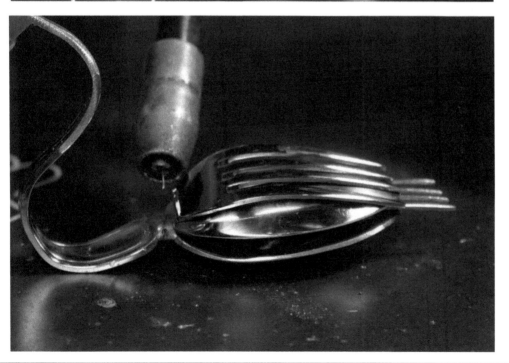

Hold one fork tine piece centered on the back of the body and tack weld it in two places.

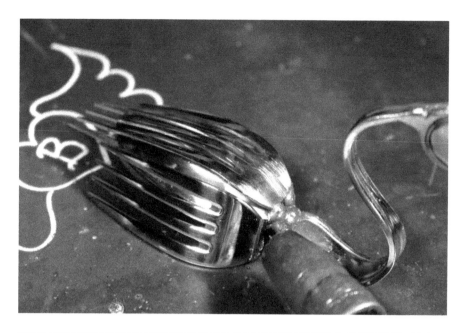

Weld one set of fork tines to each side to create feathers.

Flip the flamingo upside down and hold one leg to the center of the bottom of the left side and tack weld it in at least two places.

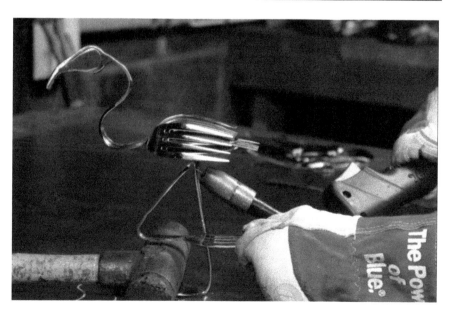

Stand him and place a hammer or something of weight on the foot to hold him upright. Hold the body on top of the leg and tack weld the second leg on. them together.

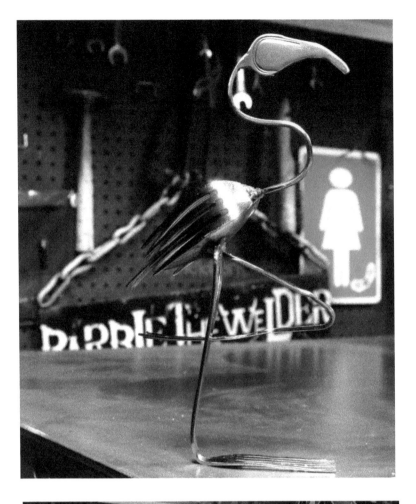

Our biggest challenge in making the flamingo will be balancing it on one foot. This we will achieve with the positioning of its head and neck, and by using the tailfeathers and placement of the legs as counterweight.

If you pick your weight off his feet and he balances the first time you need to come work with me because I have yet to manage that feat! Usually you will need to bend and move his head and neck to put more weight over his foot or tilt him backward slightly where his legs meet his body. The idea is to make small changes and keep checking the balance. When he is properly balanced you should be able to push him a little and have him stay standing.

Clean any weld discoloration and a hammer and chisel to clean any spatter.

Porcupine (Forkupine)

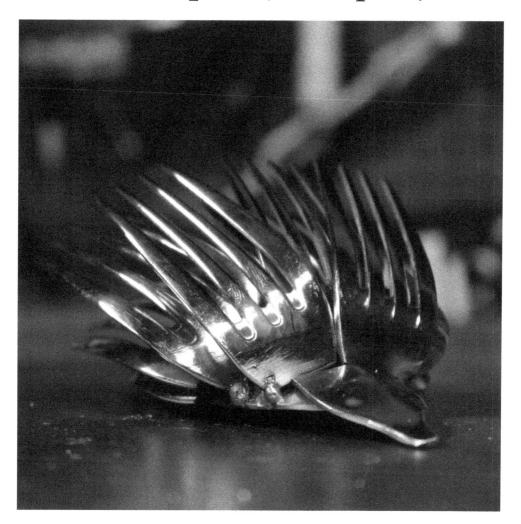

Difficulty Level

🍴🍴🍴🍴🍴

Materials:
- 1 large spoon
- 13 forks

Tools:
- Vise
- Grinder with a cutoff wheel and sanding disk
- Hammer
- Paint pen or marker

Mark and cut one fork 1/2" up from the handle base position and then cut the tines off to create the head.
Mark and cut the remaining silverware at the handle base position to create the quills and body.

Clamp the head in the vise sideways and hammer in over slightly to give it a curve that matches the curve of the spoon.

Hold the spoon on the head 1/2' overlapping and tack weld the head onto the body in two places evenly spaced. This will create heat marks on the opposite side creating eyes.

Tack weld heat mark eyes.

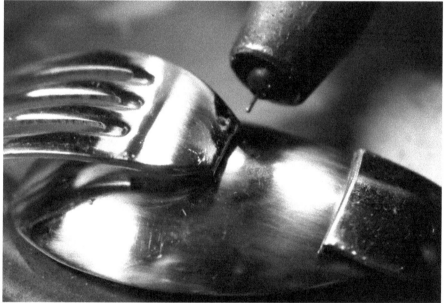

Starting in the middle of the body, tines facing backward, hold a fork and tack weld it in position using two small tacks.

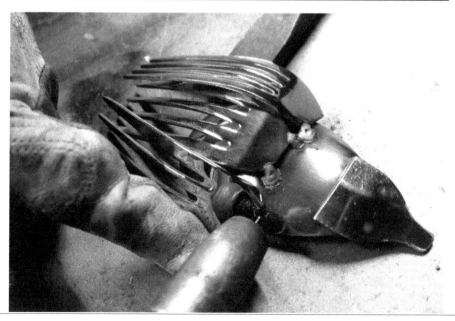

Weld one set of tines to the left and another to the right staying on that same line. The tines on the left and right forks will overlap the center tines.

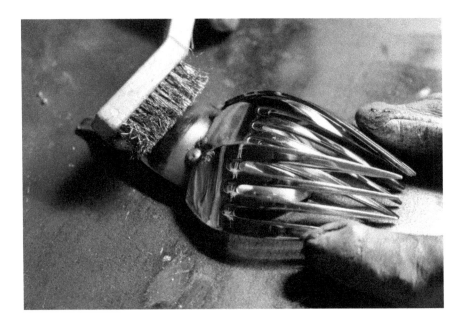

Clean the weld discoloration with a wire brush before starting the next row of quills.

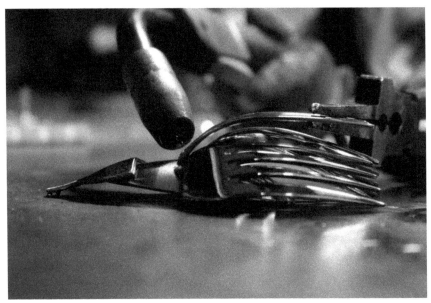

Start a second row by holding another fork in the center slightly forward from the first row and tack weld them in place.
Tack weld two more sets of fork tines to this row the same as the first row. Clean any weld discoloration.

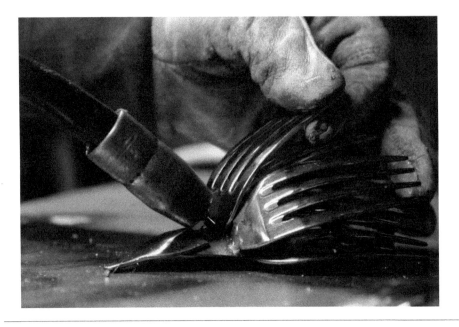

Weld and clean a third row of quills.

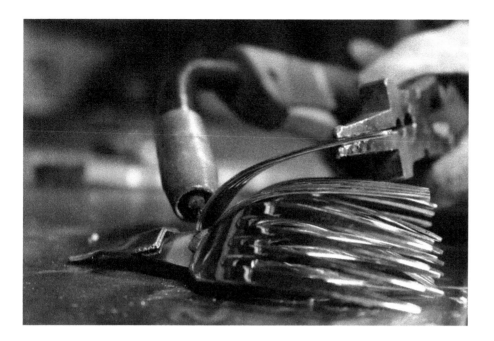

Start the fourth row by welding one set of tines in the center and slightly forward from the third row. Clean any weld discoloration.

The final two tines will be welded on in front of the previous center tine and slightly angled in either direction.

Clean any weld discoloration with a wire brush and chip any spatter with a hammer and chisel.

Show Me The Bunny!

To show me your beautiful silverware animal sculptures, have a chance for them to be featured on my social media, and win a one of a kind sculpture, post your pictures and tag

#BarbieTheWelderAnimals

I will be featuring one sculpture a week on my Instagram channel and will be choosing a winner from those featured at the end of the year! Sometimes I will choose the weekly winner and sometimes I will let everyone vote for a winner so make sure you follow my page @BarbieTheWelder and turn on notifications so you don't miss your chance to be featured and win!

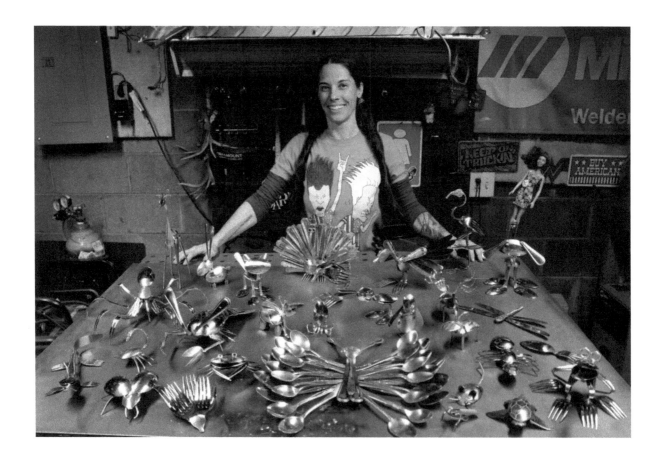

About Barbie

I took a 6 month welding program in 2007 after seeing the woman welding giant angel wings in the movie Cast Away starring Tom Hanks. The scene just spoke to my soul and I immediately knew I *needed* to be a metal sculptor. I was hired at a custom fabrication shop in 2008 after I graduated and worked there 4 years before I was able to save enough for a down payment to purchase a home, for the garage. It took me 9 more months of working and saving before I had enough to purchase the machines and tools I needed for my home studio, my 1 car garage. I quickly went to work designing and creating anything I could think of after work every day and on the weekends. I left the fabricating job I loved to create sculpture full time September 1, 2014.

Since that time I have failed my way to success! I knew nothing about selling, marketing, branding, or social media, all the things that make a business successful in today's marketplace. It took me almost a year of working full time and failing before I realized I needed to learn how to run my business like a business. I started spending hours each night, after working in the shop all day, reading business books and watching YouTube videos to teach myself all the important aspects of running a successful business. I started attending a business master mind group locally that gave me support and priceless knowledge helping me take my business to another level! I tirelessly worked to improve myself and my business in any area I saw was weak and my business and my brand began to grow.

Over the last four years I have sculpted a life for myself that is beyond my wildest dreams and keeps getting better! So far, I have had the honor of designing and creating sculptures for major corporations, small businesses, and exclusive clients in 14 different countries and have even presented sculptures to my clients live on stage at concerts! Each month my YouTube channel draws viewers from more than 50 countries, and so far including this one I have written three books! I'm still working from my one car garage at my home in Erin, NY and saving to purchase land and a larger studio.

Connect with me on Instagram and Facebook @barbiethewelder to see my most recent sculptures and shenanigans.

View my YouTube channel, Barbie The Welder, where I teach you how to weld art, share my creation process on my masterpiece sculptures, and have some no BS advice for entrepreneurs.

Commission your own masterpiece today by visiting my website www.BarbieTheWelder.com or view and purchase my available sculptures through my Etsy shop, www.Etsy.com/shop/BarbieTheWelder

Printed in the USA
CPSIA information can be obtained
at www.ICGtesting.com
CBHW051414030824
12612CB00035B/1373